IMAGES
of America

WILMINGTON

APPROVAL BY WILMINGTON CONSOLIDATION COMMITTEE.

We, the undersigned, members of and representing the Consolidation Committee of the City of Wilmington, having carefully considered the report of the Los Angeles Consolidation Committee to the City Council and the Civic Bodies of the City of Los Angeles, stating the terms and conditions under which they recommend the consolidation of Wilmington and Los Angeles, hereby approve said report, and we recommend that immediate steps be taken to bring about the union under one municipal government of Wilmington and Los Angeles for the purpose of developing the Harbor at Wilmington, commensurate with its natural advantages.

(SIGNED)

E. Opp,	D. R. Woods,
John Schneider,	P. J. Picherie,
P. J. Watson,	Henry S. Schneider,
N. F. Stone,	H. E. Gannaway,
D. C. Fohl,	W. S. Moore,
Chas. Menveg,	F. F. Breen.
F. S. Cary,	

On June 8, 1909, the Wilmington and San Pedro Consolidation Committees approved the consolidation of Los Angeles.

ON THE COVER: The Wilmington Brass Band stands in front of White's Saloon, located on Canal Street, currently Avalon Boulevard. This photograph was taken by Joseph Brent Banning (JBB Photo) around 1880. (Courtesy of Friends of Banning Museum.)

IMAGES
of America

WILMINGTON

Simie Seaman and Hank and Jane Osterhoudt, Wilmington Historical Society
Susan Ogle, Drum Barracks Civil War Museum
and Michael Sanborn, Banning Residence Museum

ARCADIA
PUBLISHING

Published by Arcadia Publishing
Charleston SC, Chicago IL, Portsmouth NH, San Francisco CA

Printed in the United States of America

Library of Congress Catalog Card Number: 2007935828

For all general information contact Arcadia Publishing at:
Telephone 843-853-2070
Fax 843-853-0044
E-mail sales@arcadiapublishing.com
For customer service and orders:
Toll-Free 1-888-313-2665

Visit us on the Internet at www.arcadiapublishing.com

This book is respectfully dedicated to Phineas Banning, whose vision, determination, and entrepreneurial spirit gave rise to the founding, development, and legacy of Wilmington, California.

CONTENTS

ACKNOWLEDGMENTS

The authors of this book would like to thank the following for their assistance:

• All the wonderful pioneer families, past and present, who developed and live in the Banning Wrigley Historic District. You gave and you continue to contribute to its character and history. Thank you for sharing your photographs, memories, and interest in preserving the architectural charm and beauty of the historic neighborhood.

• Kerr Lee, for his valuable technical help in scanning the images and materials.

• Joe McKinzie for advice and encouragement.

• Olivia Cueva-Fernandez and Steve Hoffmann for proofreading assistance.

• Van Penales of the Calvary Presbyterian Church.

• Lana Hollis.

• Bob Seaman.

• Tara Fansler, Banning Residence Museum Historic Site curator, for her photographic research for this project.

The Banning Residence Museum would like to thank the Friends of Banning Museum for the use of their photograph collection. All images in chapter one are from the archive of the Friends of Banning Museum. The Drum Barracks Civil War Museum would like to thank the Drum Barracks Garrison and Society for the use of their photograph collection. Images in chapter two, except those noted, are from their archives. In chapters three through seven, all images are from the Wilmington Historical Society Archives, unless otherwise noted.

The Banning Residence Museum is a facility of the City of Los Angeles Department of Recreation and Parks and is operated in cooperation with Friends of Banning Museum. The Drum Barracks Civil War Museum is a facility of the City of Los Angeles Department of Recreation and Parks and the State of California Department of Parks and Recreation and is operated in cooperation with the Drum Barracks Garrison and Society.

We hope readers will enjoy the following pages and find a rekindling of interest in their community's heritage.

—Simie Seaman, cofounder, Wilmington Historical Society
Hank and Jane Osterhoudt, Wilmington Historical Society
Michael Sanborn, director, Banning Residence Museum
Susan Ogle, director, Drum Barracks Civil War Museum

INTRODUCTION

The fascinating saga of Wilmington, the "Heart of the Harbor," is traced with photographs in this volume from its mid-19th-century beginnings to its stature, by the mid-20th century, as one of the world's most active ports. Originally part of the 1784 Spanish land grant of Rancho San Pedro, and called New San Pedro in 1858, the city became Wilmington in 1863, named by Phineas Banning after his Delaware birthplace. This thriving community was the center of great growth and activity and continues its prominence today, joining with its fellow City of Los Angeles neighborhood San Pedro to form one of the largest ports in the world.

PHINEAS BANNING AND THE FOUNDING OF WILMINGTON

Phineas Banning's legacy is also the story of Wilmington, California. Their beginnings, growth, and transformations were inextricably entwined during the middle half of the 19th century. General Banning built his home in 1864 in Wilmington as a symbol of his confidence in the future of his port community. Originally known as Eucalyptus Grove, the Banning residence consisted of approximately 222 acres of ranch and farmland. Today it is one of the most significant historic sites and museums in California because of its architectural quality and historical associations. The residence represents three generations of an important early Southern California family that played a significant role in the development of the Los Angeles Harbor area.

PORT DEVELOPMENT

Phineas Banning's determination to make Wilmington into a major port earned him the title "Father of the Harbor"—and what a harbor it has become. Officially founded in 1907 as the Port of Los Angeles with the concurrent establishment of the Harbor Commission, this one-time shoreline of San Pedro Bay has grown to be one of the nation's busiest ports, with 43 miles of waterfront and 27 cargo terminals spread out over 7,500 acres.

The first railroad, constructed by Banning and his business partner, Benjamin Wilson, in 1869, was the Los Angeles and San Pedro Railroad, which ran down Alameda Street. It was a 21-mile stretch of rail line from the port in Wilmington to Los Angeles. By 1876, Banning had persuaded the Southern Pacific Railroad to bring its lines through Los Angeles and connect with the Los Angeles and San Pedro line to the ports of Wilmington and San Pedro. This would bring the port access to a transcontinental rail network, a major achievement that guaranteed growth for the entire area.

The first breakwater was begun in 1871. By 1873, it was completed, and the main channel of the harbor had been dredged to allow for larger vessels the same year. The port became a legal port of entry in 1874, complete with a customs house. In 1889, a larger, outer breakwater was constructed. Major harbor improvements continued to be made, the Panama Canal opened in 1914, and the Port of Los Angeles expanded to meet the requirements of new shipping technologies. Banning, who died in Wilmington in 1885, could not help but be pleased that his wharf and railroad have grown to become America's busiest container port.

Protecting the harbor became a major issue as the Civil War began in 1861. Banning and Benjamin Wilson (who was the second mayor of the city of Los Angeles) offered 60 acres of land to the U.S. government to build a military post and secure Southern California for the Union. First called Camp Drum, it was named Drum Barracks as permanent structures were built in 1862 to replace tent encampments. As a staging area and supply depot, it served forts all over the southwestern territories, conveying men, arms, and supplies. It served its purpose in protecting the harbor and keeping the peace, cooling down local Confederate sympathizers, and keeping California firmly for the Union. It also brought people, trade, and growth to the port and Wilmington.

CHURCHES, SCHOOLS, AND BUSINESSES

Central to community development are churches, schools, and businesses. In Wilmington, the first church, the Roman Catholic Church of SS. Peter and Paul, was founded in 1865, followed by the Memory Chapel Presbyterian Church in 1870 and St. John's Episcopal Church in 1882. The first U.S. Post Office opened in 1864, and the first school, a four-room building, was constructed in 1865 on land contributed by John Downey.

Wilson College opened in 1874 and is believed to be the first coeducational college west of the Mississippi. Active for several years, it closed after the Methodist Church Conference received a large donation of land closer to Los Angeles and decided to develop on that site. Opened in 1880, that new college would become the University of Southern California. The next college to open in Wilmington was Los Angeles Harbor Junior College in 1949, an institution that became an important link in the state junior college system.

The Wilmington Library Association was formed in 1908 as local ladies opened a reading room in the Wilmington Town Hall, located at I Street and Avalon Boulevard, where Town Square Park sits today. The first Wilmington Branch Library of the Los Angeles Public Library system was built in 1927, and it served the community until 1988, when a new Wilmington Branch Library opened its doors to the public.

Business found a thriving home in Wilmington as the port and railroad served as economic engines. Among the city's early impressive structures was the 1907 Wilmington City Hall, which was classical in design and built by Los Angeles architect C. H. Russell. The two-story building housed the fire department in the basement and offices for the treasurer, marshal, tax collector, and street department on the first floor. The council chamber and the library were located on the second floor. The building was destroyed during the devastation of the 1933 Long Beach earthquake.

In March 1923, architect Edwin Bergstrom was retained to prepare sketches and drawings for the California Yacht Club, and the completed clubhouse was dedicated in time for summer sailing. During World War II, the U.S. Coast Guard commandeered the clubhouse for the war effort.

C. W. Post of the Post Cereal family built the Granada Theater in 1926 as part of the West Coast Theatres chain. One year later, Fox Theatres purchased West Coast and changed the name to the Fox Granada. The highlight of the Granada was the advertising curtain. The *Wilmington Press* building was built by architect Sid Spearin in 1929. Spearin felt that the construction of the newspaper building was one of the most important events in the growth of Wilmington. The building, located at 618 Avalon Boulevard, is still intact.

ANNEXATION

It was hard to resist the promised advantages that could be provided by joining with the city of Los Angeles: new schools and libraries, police and fire services, harbor improvements, improved water supplies, and more. Eventually both Wilmington and San Pedro agreed to annexation, and on June 8, 1909, the consolidation with Los Angeles was approved by the Wilmington and San Pedro Consolidation Committees.

NEIGHBORHOODS

College Hill, the area around Wilson College and the former Drum Barracks post, was a popular residential neighborhood in the 1870s. New homes were built and families flourished. Decades later,

another unique neighborhood was formed; especially well known today, it has been designated as a Historic Preservation Overlay Zone (HPOZ) in Los Angeles. First designated the original "Court of Nations," it is recognized today as the Banning Wrigley Historic Neighborhood.

In early January 1919, William Wrigley Jr. purchased Santa Catalina Island sight-unseen from the Banning brothers, sons of Phineas Banning. Included in the purchase was the Wilmington Transportation Company, which provided transport from the mainland to the island. Wrigley had a clear vision of what the island would become: "A first class resort." And as the island became a vacation destination, the community of Wilmington and the waterfront at the foot of Avalon would serve as the departure point for millions of tourists. Thus Wrigley began his connection to Wilmington.

In August 1923, Wrigley visited Wilmington and foresaw a great future for the city. He predicted that Wilmington, as a harbor city, was bound to become a close rival of New York within a few years. Both Wrigley and Henry Ford, of the Ford Motor Company, invested $1 million in Wilmington by February 1927. These investments showed beyond all doubt the confidence of Wrigley in Wilmington and led to the formation of the Fleming and Weber Company, an investment and real estate concern. One of the tasks of the Fleming and Weber Company was to build 100 custom homes on the old Banning homestead for elite businessmen associated with the Wilmington Transportation Company and Ford Motor Plant, as well as for area community professionals.

The designing and construction of these homes was awarded to local architect Sid Spearin, who designated the neighborhood as the Original Court of Nations and proceeded to design homes that would be architecturally distinctive in plan and style. Today the 1200 blocks of Lakme Avenue, Banning Boulevard, and Cary Avenue of the Banning Wrigley neighborhood have been designated a City of Los Angeles Historical Preservation Overlay Zone. With this important landmark status, they will be preserved for future generations. Special tours of this unique neighborhood are offered in Wilmington.

WORLD WAR II AND WILMINGTON

The Second World War brought enormous changes to Wilmington as it did to many cities around the country. Men and supplies arrived and departed, flowing through the port in staggering numbers. The Los Angeles Port of Embarkation (LAPE) at Wilmington originated with Col. William A. Aird Jr. on January 24, 1942. Los Angeles Port Embarkation's mission was to receive, supply, transport, embark, and debark troops, supplies, materials, and equipment for the war effort.

Aird set up office in rooms 209 and 210 at Pier 155, borrowing furniture from the American President lines. Two days later, he acquired a secretary and file clerk and borrowed troops from Fort MacArthur to work half-day shifts to unload transports. As the number of transports grew, Aird struggled to find crews in city jails, local bars, and the Seaman's Institute.

LAPE was a sub-port of San Francisco until October 1, 1943, when it attained independent status, becoming directly responsible to the chief of transportation in Washington, D.C. Immediate additions to the LAPE included the completion of a station hospital at Vermont Avenue and Carson Street (in the unincorporated Los Angeles County area that is now the city of Carson), three huge warehouses of 300,000 square feet each, and railroad holding yards capable of handling 6,600 cars. The warehouses were called the Manuel Warehouses, located north of Pacific Coast Highway in Wilmington, on the east side of the Texaco Refinery. Camp Anza near Riverside was also part of LAPE.

Because of the importance of the Los Angeles Port Embarkation, Wilmington was a major West Coast defense area. Within a four-mile radius were five major shipbuilding yards. One of the largest yards was Consolidation Steel Corporation, located at Neptune Avenue and B Street. Construction on the yard started August 2, 1941, with 40,000 piles, several miles of docks, and three miles of railroad tracks, covering 95 acres at a cost of $10 million. The shipyard constructed destroyers, escort vessels, landing craft, tank lighters, large troop carriers, cargo vessels, and naval ordnance for the U.S. Navy.

These massive endeavors created a need for war workers from all over the United States, all requiring housing. Constructed at 435 Neptune Avenue were huge two-story dormitories called Wilmington Hall with 2,126 double and single furnished rooms. Provided for workers were barbershops, a library, laundry, theater, gymnasium, music rooms, community store, infirmary, and two all-night cafeterias.

Dana Strand and Normont Terrace were the accommodations constructed for war workers with families. Filling every available space north of B Street, the U.S. Army constructed temporary housing for the overflow. The local newspaper estimated the number of shipyard workers at 90,000. The folks of Wilmington should be commended for their sacrifices and contributions to the war effort, which today are in danger of being forgotten.

From the Drum Barracks Headquarters of the Southwest in the Civil War to the extensive maritime activity that took place here in World War II, Wilmington has a long history of commitment to and involvement in our country's military.

CONCLUSION

While we realize there is much more to Wilmington history, we had to select only a few areas of interest to include in the space available. Visit the Wilmington Historical Society, Banning Residence Museum, and Drum Barracks Civil War Museum and tour the Banning Wrigley Historic District to learn more about these and many other areas of Wilmington's amazing, diverse, and fascinating history.

Generations of people arrived, developed businesses, raised their families, built churches and schools, and called Wilmington home. We hope these images of people and places, and the results of their life and labor in Wilmington, will recall memories and renew interest in our shared community history.

One

PHINEAS BANNING AND THE FOUNDING OF WILMINGTON

Phineas Banning was born in Wilmington, Delaware, in 1830. By the age of 20, Banning had built a reputation as a reliable source to move all manner of goods at the Philadelphia waterfront. In 1851, he was hired to transport cargo to Southern California. Soon after his arrival in California, Banning entered the world of staging and freighting, driving six-horse stages from the port to Los Angeles and beyond. Banning was the driving force in building the Port of Los Angeles, constructing the first breakwater, and dredging the harbor. He also ran an extensive network of stage and freight routes that connected the newly established port east to San Bernardino and south to Fort Yuma. As a California state senator, Banning also succeeded in bringing the first railroad to Southern California, the Los Angeles and San Pedro. Phineas Banning remained in the Los Angeles Harbor area from his arrival in 1851 until his death in 1885. He is fondly referred to as the "Father of the Los Angeles Harbor."

This *c.* 1878 artist's conception of Wilmington shows Banning's Landing with wharves, warehouses, and a transcontinental railroad connection. In 1854, Banning, along with a group of investors (B. D. Wilson, W. T. B. Sanford, and J. G. Downey), purchased 2,400 acres from the Dominguez family for $12,000. Four years later on September 25, 1858, the first group of freight and passengers

arrived in New San Pedro. By 1863, Banning had the name of the town officially changed to Wilmington, after his birthplace. Banning's estate can be seen in the middle with Los Angeles in the upper right corner. Adjacent to Banning's property is Wilson College, formerly Drum Barracks, the Civil War military reservation established in 1862.

Wilmington Exchange Hotel, seen in a c. 1870 photograph, was located on Canal Street (currently Avalon Boulevard). The hotel was the first in Wilmington and was completed in 1863. The single-story building attached to the hotel was the first Wilmington home for Phineas Banning and his wife, Rebecca. One of Banning's stagecoaches can be seen in the foreground full of passengers.

Downtown Wilmington is seen looking north on Canal Street. The c. 1880 photograph was taken by Joseph Brent Banning, the middle son of Phineas and Rebecca Banning. His photographs were labeled "JBB Photo." Located on the left is the general mercantile store owned by P. H. Downing. Banning had employed Downing during the Civil War to supply the government wagon trains heading east. After the war, Downing stayed in Wilmington and opened his own business.

The stationery store of Louis Lewin was located on Canal Street, seen in this c. 1880 JBB Photo image. Lewin came to Los Angeles in the late 1860s from Tucson and bought several of the largest then existing stationery businesses, creating one of the first chain-store printing services in Southern California.

Canal Street, looking south around 1885, is seen in this Joseph Brent Banning photograph. The large brick two-story building in the center of the image is the Wilmington Masonic Temple, Lodge No. 198, built in 1882. The building was moved in 1912 to its present location at 227 North Avalon Boulevard. This building is considered one of the oldest nonresidential structures still standing in Wilmington.

This image of the Chinese laundry business of Lee Sing, located near Banning's Landing, was taken by Joseph Brent Banning around 1880.

The Laubershimer family residence in Wilmington is seen here. In 1871, Gov. Newton Booth reappointed Phineas Banning as a brigadier general in the California State Militia. This was the same position Banning held during the Civil War. Banning appointed H. M. Laubershimer as chief surgeon on his staff. This image was taken by Los Angeles photographer August Blix around 1880.

The Banning machine shop for the Wilmington Transportation Company was located on Canal Street near Banning's Landing. Banning's shops were responsible for producing freight wagons, stagecoaches, railroad cars, and tugboats from the 1860s through the 1880s. This "stereoview" image was taken by Joseph Brent Banning around 1880.

The Wilmington railroad yard was located at First and A Streets. Banning's warehouses can be seen in the background of this c. 1885 JBB Photo image along with stacks of railroad ties for the Southern Pacific Railroad.

The Wilmington Town Hall interior, seen here, was built in 1870 by Phineas Banning. This image was taken in 1898, depicting officers of the Republican Club standing in support of the McKinley/Hobart presidential campaign. The old town hall was eventually converted into a rigging loft and was demolished in 1932.

Canal Street, looking north, is seen around 1885 in another image shot by Joseph Brent Banning. The three dark-colored, large, two-story buildings on the right are Banning's machine shops. The Masonic Temple can be seen in the background at the center.

The *Warrior I* was purchased by Phineas Banning in the 1880s and brought down the coast from Washington state. The tug was rebuilt and put into service as a passenger vessel for the harbor and for cross-channel trips to Santa Catalina Island. The Wilmington Transportation Company retired the ship in 1901, and it became a seaman's chapel. It was located on a mud flat near Terminal Island in San Pedro until it fell into complete disrepair. This image was taken by Joseph Brent Banning around 1890.

The *San Gabriel* was the first locomotive engine in Southern California. This "pony" engine was one of two built by the Vulcan Iron Works of San Francisco for the Napa Valley Railroad. The engine had a pair of 54-inch drives with a single forward axle. It was delivered to San Pedro on January 12, 1869, by the schooner *Parallel*. The *San Gabriel* hauled construction materials during the building of the Los Angeles and San Pedro Railroad, which was completed and opened for service on September 8, 1869. This photograph was taken by Los Angeles photographer William Godfrey in 1870.

This oldest known photograph of the Banning home was taken in 1870. In 1864, construction was completed on the residence. It was located approximately two miles from downtown Wilmington, near Banning's Landing. The home sat on 222 acres and was a working ranch. This image was taken by William Godfrey while he was on commission to take photographs of the harbor for the U.S. Army Corps of Engineers.

The Banning barns are seen in this c. 1885 view looking south toward the back of the residence. The three-pediment barn located in the middle of the photograph is the only one still standing today. Originally there were three barns of identical dimensions that served as a foundry, bunkhouse, and stable.

William Sanford Banning (1858–1946) was the eldest son of Phineas and Rebecca Banning. After the death of his father in 1885, William became the patriarch for the family and ran the Wilmington Transportation Company along with his brothers until the company was sold to the Wrigley family in 1919. William was also known for his skills as a stagecoach driver and continued driving his coaches well into his 80s.

The Banning residence garden is seen looking east. This c. 1890 image shows the grounds in the early stages of a residential garden setting. After the death of Phineas Banning, the family began to change the look and use of the property from a ranch to a domestic venue.

The Banning residence is seen looking through the eucalyptus trees that lined the front entry. This photograph was taken by August Blix around 1885, close to the time of Phineas Banning's death.

The Banning residence stagecoach barn is depicted in 1888. The image shows a family gathering for an outing. The stagecoach (mud wagon) on the right-hand side is one of Phineas Banning's original vehicles, which he used in transporting people from the harbor to downtown Los Angeles and beyond. This image was taken by Los Angeles photographer A. C. Golsh.

The Banning residence is seen here around 1880 in a Joseph Brent Banning photograph considered to be the third-oldest image of the home. Standing on the porch is Mrs. Derby, who was a nanny for several of the Banning children.

Joseph Brent Banning (1861–1920) was the second-oldest surviving son of Phineas and Rebecca Banning. Joseph and his wife, Katharine Banning, moved into the home in 1888 and stayed until 1893. Joseph was also an accomplished amateur photographer who would often scratch his initials into the glass-plate negative. By analyzing the dates that he inscribed on the negatives, we know that he began taking photographs as early as 1880. He continued taking photographs as late as 1915, just five years before his death, leaving a 35-year visual history.

The Banning residence is on view here around 1900. From 1894 to 1908, the home was inhabited by the family of Andrew Young, an employee of the Wilmington Transportation Company. While the Young family lived in the home, no improvements or changes were made for nearly 14 years.

The Young and Banning families are having a carriage race on the east side of the home in this image from 1905. Exposed on the roof are the second-floor bathroom vent pipes. The first bathroom was installed in the house in 1893 by Joseph Brent Banning.

The Banning residence is seen from the west side around 1910. Located on the roof are two solar panels for heating water. The solar heating system was placed in the home by Hancock Banning and remained until the early 1920s. The hot-water storage tank is still in place, located in the cupola.

Hancock Banning (1865–1925) was the youngest surviving son of Phineas and Rebecca Banning. Hancock and his wife, Anne Ophelia Smith, moved into the home in 1908 and remained until Hancock's death in 1925. They are credited with bringing the home into the electrified 1900s. They also changed some of the architectural features along with installing a sunken patio and ballroom in 1912.

Silent picture filming occasionally took place at the residence. The 1927 movie *Topsy and Eva* was partly filmed at the home. Over the years, there have been dozens of movies filmed at the residence, with the most recent being *Primary Colors* in 1998.

Mary Hollister Banning (1871–1953) was the oldest surviving daughter of Phineas Banning and his second wife, Mary Hollister. Banning remarried in 1870, two years after the death of his first wife. Mary Banning, along with her mother and younger sister Lucy, moved away from the residence and relocated to Los Angeles after her father's death in 1885.

The Banning residence is seen in 1930 with William Banning standing on the porch. The residence and adjoining 20 acres were sold to the City of Los Angeles in 1929, becoming part of the city's recreation department. After the death of Hancock Banning in 1925, the surviving family members made the decision to let the property become grounds for public use. The district bond issue authorizing the purchase passed on June 23, 1927, by a large margin.

Lucy Banning (1876–1929), the youngest surviving child of Phineas and Mary Banning, was known for her beauty. She was considered one of the most beautiful women in California during the 1890s. Lucy married several times and, like her sister Mary, did not have any children.

These wisteria vines at the Banning residence were planted in 1908 by Hancock Banning. Both Japanese and Chinese vines have been growing at the home for nearly 100 years. In 1953, the Wilmington Chamber of Commerce began an annual Wisteria Festival held on the grounds of Banning Park.

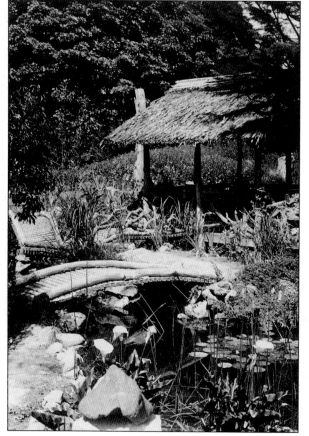

This Japanese Tea Garden was located near the residence around 1920. Hancock Banning transformed the landscape around the Banning home into a lush residential garden setting, complete with canals, earthen amphitheater, ponds, bridges, and orchards. Banning Park today still retains a few of these historic elements.

Two

KEEPING CALIFORNIA FOR THE UNION

Col. James Freeman Curtis poses with his staff in March 1865. From left to right are (seated) Lt. Col. Richard Hillyer, Colonel Curtis, and surgeon Vincent Gelcich; (standing) Lt. Orlando Lee, adjutant, and Capt. Matthew Sherman, quartermaster. Curtis was given command of the 4th California Infantry, Camp Drum, and the Military District of Southern California on June 25, 1863. Construction of the post's permanent buildings was nearly completed when he arrived in Wilmington. (Courtesy of U.S. Army Military Institute, Carlisle, Pennsylvania.)

— The Drum Barracks. —

PICKET FENCE

* OFFICER'S QUARTERS

W

ORDINANCE

ORDINANCE

MAGAZINE

PARADE GROUND

* FLAG POLE

ADJUTANT'S OFFICE

COMPANY QUARTERS

OUT-BUILDINGS

GARDEN

HOSPITAL

GUARD HOUSE

STABLES

LAUNDRIES

* STRUCTURES STILL STANDING IN PLACE

ONE INCH EQUALS 200 FEET

This diagram shows the layout of the 60-acre military post in 1862. Today the Drum Barracks Civil War Museum is housed in the last remaining wooden structure, the Junior Officers' Quarters. There were 22 buildings, including five barracks each holding 100 men, a two-story hospital, Commanding Officer Quarters, Senior Officers' Quarters, Junior Officers' Quarters, Adjutant Office, guardhouse, laundry, bake house, musicians' quarters, powder magazine, hospital steward's quarters, and two stables. Drum Barracks was first a tent camp in late 1861, with the wooden structures built in 1862 and 1863. Located a mile from the waterfront, this army headquarters for California and the Arizona Territory was intended to keep the state of California in the Union by protecting the harbor, keeping the peace, and serving as a supply depot for Western forts. This diagram does not show an additional part of the post, a parcel of about five acres on the waterfront often called the U.S. Depot or Government Depot, where warehouses were built to store supplies coming in by ship.

30

This is the only known photograph of a camel in California during the Civil War. It was taken by French photographer Rudolph D'Heureuse as he made his collection of "41 Photographic Views of the Mojave Route, El Dorado Canyon, and Fort Mohave, 1863." Taken at the section of the Drum Barracks called the U.S. Depot or Government Depot, it shows a two-humped Bactrian camel standing in front of one of the government warehouses. Two shiploads of camels were imported to Texas in 1856–1857 in an experiment using them as pack animals in the southwestern deserts. In 1867, Edward Fitzgerald Beale and his men used 25 camels while surveying for a wagon road from Fort Defiance across the 35th parallel to the Colorado River at Fort Mohave, ending at Fort Tejon in California. When war began in 1861, Fort Tejon was temporarily closed and the soldiers sent to Drum Barracks, bringing 36 camels with them. The government did not support further importation of camels and ordered them sold at auction at Benicia Barracks in November 1863.

This image of the Senior Officers' Quarters, shown in the 1920s, is captioned "Old home of Tom T. and his daughter-in-law, Wilmington, Calif." After decommissioning by the army, the land reverted to Banning and Wilson and the structures were sold at auction in 1873. Banning and Wilson bought many; others were purchased for barns or homes on other sites. Soon the former military post became a popular and attractive new neighborhood in Wilmington.

This is believed to be the hospital steward's building in the 1920s. In 1874, Benjamin Wilson donated two buildings and land from the Drum Barracks site to the Methodist Church to create Wilson College, the first coeducational college in the West. It continued for two years, then closed, as plans were made to develop a larger site nearer Los Angeles; the new site opened in 1880 and became the University of Southern California.

Seen here about 1885, the Senior Officers' Quarters was a two-story structure on the west side of the post. A man with a horse and buggy can just be seen in front of the building. Single-story wings extended to the north and south and a balcony wrapped around three sides of the second floor. (Courtesy of the Huntington Library, Art Collections, and Botanical Gardens.)

The Junior Officers' Quarters is the only wooden building that survived, and today it houses the Drum Barracks Civil War Museum, which opened in 1987. The two-story building, with two wings extending from the west side of the structure, shows a porch and balcony at the front. Both officers' quarters buildings were at the west side of the post near what is Banning Boulevard today.

Richard Coulter Drum was the acting adjutant general for the Department of the Pacific in San Francisco when a military post was proposed for Wilmington. His determined efforts to establish the post resulted in its being named in his honor. The name was changed in the fall of 1863 from Camp Drum to Drum Barracks, an appropriate title for its role as a major supply, training, and staging base.

Col. James Carleton, first commanding officer at Drum Barracks, led the California Column of 2,350 soldiers in an 1862 march across the deserts of California, Arizona, and New Mexico to force invading Confederate soldiers back into Texas. This effort to invade the West was part of Confederate plans to take over the port at Wilmington, circumvent the naval blockade in the East, and create a Confederacy stretching from the Atlantic to the Pacific. Don McDowell painted this portrait of Carleton.

Col. James Curtis arrived to take command of the 4th California Infantry, Camp Drum, and the Military District of Southern California in July 1863. He enforced civil and military law and order, maintained a strong Union presence, and supervised military posts from Visalia and the Owens Valley to San Diego and the Colorado River. He served at Drum Barracks longer than any other commander. (Courtesy of U.S. Army Military Institute, Carlisle, Pennsylvania.)

The Commanding Officer's Quarters, seen here prior to 1917, was a one-story structure with a porch wrapping around the main part of the building. Wood for the 22 buildings at the post was brought from New England, cut to size, and shipped around the Horn of South America. This contributed to the estimated $1 million construction cost of the post.

The guardhouse, where troublemakers were housed, was still in good condition as seen prior to 1910 but deteriorated greatly in subsequent years. After decommissioning in 1873, the land, originally donated to the government for use as a military post by Phineas Banning and Benjamin Wilson for $1, was returned to them. The buildings were auctioned off, with some moved away for barns, housing, or other uses. None remain today except the Junior Officers' Quarters housing the Drum Barracks Civil War Museum.

The Quartermaster's Depot, located on a part of the Drum Barracks military post often called the U.S. Depot or Government Depot, is shown here in 1903. The right-hand building was being used as the town hall at this time. The government's warehousing on the waterfront was built to conveniently unload and store supplies coming in by ship.

Local young men stage a mock incarceration at the powder magazine around 1900. At left, one can clearly see the large initials "CH" carved into the brick. Many other paintings and photographs of the magazine show these initials, and they can still be seen on the building today.

Seen here in the 1980s, the powder magazine is a stone-and-brick structure built in 1862 to store kegs of black powder. The magazine sat on the southern edge of the post and was constructed using Palos Verdes stone quarried locally. Efforts to demolish the building met with strong community opposition in 1982, as local residents literally surrounded it to stop the bulldozer destruction. It has been designated Los Angeles Historical Cultural Monument No. 249.

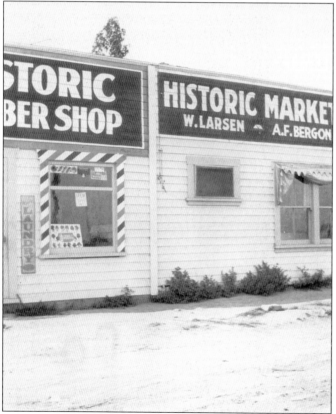

The powder magazine still stands today at the corner of Opp Street and Eubank Avenue in very poor condition. Both interior brick and exterior stone and concrete walls bear engraved initials and dates from as early as the 1880s.

A wooden building was constructed to enclose the powder magazine, extending both north and west along the entire corner of Opp Street and Eubank Avenue. In 1923, the Larsens opened the Historic Market, using the magazine for cold storage. The property was later used as a residence before being torn down in 1982. Local residents saved the powder magazine from demolition at that time.

Bodies from the Drum Barracks post cemetery were removed to Woodlawn Cemetery in Compton, California, in 1887. This April 1987 photograph, taken 100 years later, shows 14 individually marked Civil War soldiers' graves. The large monument behind the cannon marks the grave of 17 unknown soldiers. In total, 31 graves were relocated. Don McDowell, author of the Drum Barracks history *The Beat of the Drum*, took this photograph.

The monument is inscribed "In Memory of Seventeen Unknown Soldiers Moved in 1887 from Wilmington Barracks to This Hallowed Ground by Shiloh Post No. 60 G.A.R. Erected by the Grand Army of the Republic and Allied Orders 1938." These soldiers' remains could no longer be individually identified by 1887 and they, along with the 14 who were identified, were relocated to Woodlawn Cemetery in Compton. Don McDowell took this photograph as research on Drum Barracks history.

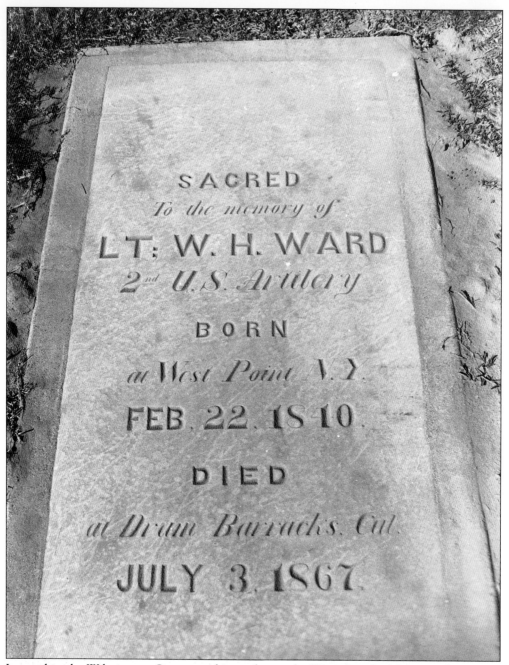

Located in the Wilmington Cemetery, this marker reads, "Sacred to the Memory of Lt. W. H. Ward, 2nd U.S. Artillery, Born at West Point N.Y. Feb. 22, 1810, Died at Drum Barracks, Cal July 3, 1867." Cemetery records show 31 Civil War veterans interred in the Wilmington Cemetery. Among those is Anton Laubershimer, who remained in Wilmington after the war, became a successful businessman, and served as Wilmington postmaster from 1869 to 1888. Another is Peter Traub, a German immigrant who remained in Wilmington after the war to farm and raise a family. His home, built in 1875, stayed in the Traub family until it was finally demolished in 1979. Another veteran here is William L. Banning, a nephew of Phineas Banning.

Tents covered the landscape as a Grand Army of the Republic (GAR) and Women's Relief Corps (WRC) reunion was held in the South Bay area in 1888. Sources place the site in Wilmington and San Pedro. (Courtesy of Security Pacific Collection/Los Angeles Public Library.)

GAR and WRC reunions were held all over the United States annually. Soldiers who had been bitter enemies sought to find common ground as Americans, and those who had fought side-by-side had an opportunity to meet and reminisce. The sign reads "Headquarters Encampment of W.R.C." (Courtesy of Security Pacific Collection/Los Angeles Public Library.)

Thomas W. and Mary Keaveny and family lived in the Junior Officers' Quarters building and ran it as a boardinghouse from about 1911 to the early 1960s. Thomas Keaveny was proud of his home's historic past; this photograph shows the dedication of a bronze marker mounted between the entrance doors, donated by the Rudecinda Parlor No. 230 of the Native Daughters of the Golden West on October 2, 1927. The military band from Fort MacArthur played for the afternoon event. Participants included "military and civic leaders of the port area." One of the speakers was Judge William H. Savage, who had been quartermaster at the post in 1866. Boy Scouts took part in the ceremony and helped direct visitors. This beautiful plaque is still on the site, mounted to the right of the brick steps leading up to the front porch.

Beautiful white rose bushes were planted in 1876 all around the Junior Officers' Quarters. Today found only on the south side of the building, they still thrive, producing small white blooms in great profusion. The unusual Scottish rose called "Lady Banksia" is believed to have been planted by Robert Mulforth Boag, a Presbyterian minister who was the first civilian resident of the building after its military decommissioning.

As pictured in 1948, alterations such as the porch and second-story balcony are visible at the back or west side of the building. Two doors have been added at the center of the second floor, presumably for fire exits, as the building was used as a boardinghouse at this time. At front is the ivy-covered well.

In 1975, the well is still a prominent feature of the west side, but the elaborate wooden balustrades and porch screen decor seen in a previous photograph have disappeared. Today the well is still visible as a brick circular structure in the courtyard, but it has been filled in for safety reasons.

Vince Manchester was the caretaker for the former Junior Officers' Quarters building from 1965 into the 1970s. A Civil War reenactor, he headed the 7th Cavalry, Company E, the "Ghost Patrol," which traveled all over the western United States. Well-versed in the history of the Drum Barracks, Manchester copied many records from the National Archives for his research purposes. He created the museum's impressive display of model buildings depicting the post in 1863.

Marga Jean Martin was named "Miss Drum Barracks" in 1965. She worked alongside her mother, Joan Lorenzen, as founding members of the Society for Preservation of Drum Barracks. Marga and her husband, Freddy Martin, often portrayed Pres. and Mrs. Abraham Lincoln at Drum Barracks activities throughout the years.

In this 1982 photograph, officers of the Society for Preservation of Drum Barracks pose for a formal portrait. From left to right are (first row) Marilyn Lofthus, President Emeritus Joan Lorenzen, Pres. Katie Papadakis, Viola Wynns, Catherine Erven, and Los Angeles City Council president John Gibson; (second row) Stephen Miasnik, John Holland, Heinz Behrend, William Moore, Marga Jean Martin, Oliver Vickery, Harold Coulthurst, Frank Alexander, Walter Holstein, and Vincent Manchester. The society was the driving force behind the purchase of the building and grounds by the State of California, the preservation and restoration of the site by the City of Los Angeles, and its opening to the public as a museum in 1987 operated by the City of Los Angeles Recreation and Parks Department.

Restoration took place in 1975–1976. The state had not made progress in plans to restore the building following its purchase in 1968, so in 1974, the City of Los Angeles signed an agreement with the State of California to restore the building and open it to the public as a Civil War museum.

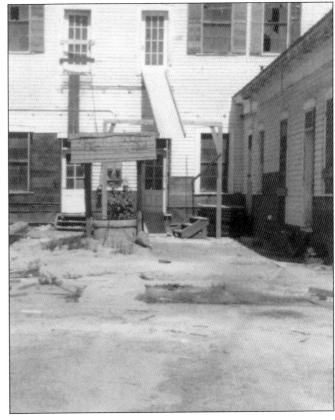

A chute for disposal of materials descends from the second floor from one of the two doors installed as fire exits in the 20th century. Both doors would be removed and the original configuration of the structure reconstructed as the massive restoration project continued.

Inside the building, walls were replastered. The four fireplace openings were closed off with bricks, but each would soon display a special set of andirons original to the building. Original floors were retained, as were windows, door frames, staircases, and as many architectural details as possible. The Drum Barracks has been designated City of Los Angeles Historic Cultural Monument No. 21, California Historical Landmark No. 169, and is on the National Register of Historical Places.

The building has 14-foot-high ceilings and the staircase seems to ascend into darkness in this 1975 photograph showing the interior restoration project. The original wooden steps and balustrade are still in use today, a testament to the careful work of the restoration crews.

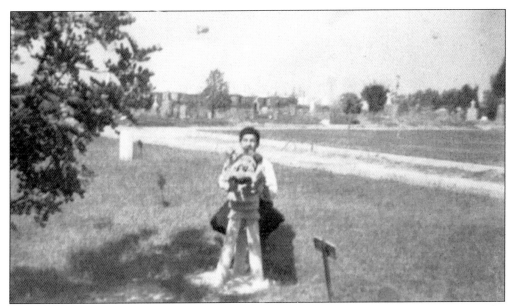

The Gatling gun at the museum is a part of both Wilmington and Civil War history. In 1924, the gun was mounted on a tripod and displayed in the Wilmington Cemetery as a memorial to Civil War veterans buried there. In 1962, it was stolen and remained missing until July 1969, when Herbert Cox of Long Beach and Joe Kerrico, a sailor from the USS *Long Beach*, discovered it in a local dump. They hauled the artifact to the police station, where it was identified by William Pashke, the caretaker of the Wilmington Cemetery. He confirmed its identity by the bullet lodged the wrong way in one of the barrels. Donated by the Wilmington Cemetery to the Society for Preservation of Drum Barracks, it was restored for the opening of the museum in 1987 and now serves as the centerpiece of the Armory. (Courtesy of the Wilmington Historical Society.)

The Junior Officers' Quarters building and grounds were purchased by the State of California in 1968. In 1974, the City of Los Angeles signed an agreement with the state to restore the building and open it as a Civil War museum. Without several decades of commitment and determination by the Society for Preservation of Drum Barracks, the site would surely have been lost to demolition.

Restoration of the building was celebrated with a gala rededication ceremony in 1980 attended by Mayor Tom Bradley, Councilman John S. Gibson Jr., Civil War troops and civilian reenactors, a fife and drum corps, and community members. It was a proud day for preservation enthusiasts in Wilmington, especially Society for Preservation of Drum Barracks members.

Three

EARLY WILMINGTON BUSINESSES

As Wilmington grew, so did the Wilmington Transfer and Storage Company. James Puckett's desire was to serve his new customers and old friends with the utmost in speed, courtesy, and service. The policy of the company was to keep in step with the wonderful progress of Wilmington and to be, if anything, just one step ahead. The van seen here in 1917 was a new addition to the company's fleet.

Three of the buildings in this 1911 photograph are still in use. The Banning brothers built the structure with the advertisement "Southern Rooms and Apartments" in 1911 at the corner of C Street and Avalon Boulevard. It is known today as the Del Mar Hotel. The building to the right of it was the office of the city health officer and contained a five-bed hospital. The third building on the left side of the street is the Wilmington Masonic Lodge No. 198, built in 1882 by Edward McDonald.

With Wilmington's consolidation with the city of Los Angeles in August 1909 came the work of deepening the inner harbor. To avoid hauling the dredging materials out of the area by wagon, workers used that material to fill the southern section of Wilmington from Anaheim to the waterfront, raising the area 10 to 12 feet. This was called the "Landfill of 1911–1913." The beehive-looking objects in the center of Canal Street are manholes that would be at grade level after the fill. Notice the Wilmington Department Store delivery wagon.

Vineyards were a common sight in and around Wilmington at the dawn of the 20th century. Many Italian immigrants made a living making and selling wine. The Melle family winery made and sold red and white wines from grapes contracted from the Poggi, Opp, Peterson, and Laubershimer vineyards in Wilmington. One Melle store was located on B Street and another on Anaheim Street until 1920, when the winemaking industry declined and they dismantled the stores.

In 1864, Banning bought the *Los Angeles Star*, transferred the paper to Wilmington, and renamed it the *Wilmington Journal*. He changed the editorial policies, which had favored the Southern cause, to support his Yankee sympathies. Numerous articles about the rush of building and the job opportunities promoted the town. The paper survived three years and helped elect its owner to the California Senate. Seen here in 1911 is the *Wilmington Journal* building at D and Canal Streets.

In 1906, architect C. H. Russell designed the Wilmington Town Hall at the corner of Avalon Boulevard and I Street. It was classic in design, with tall columns decorating the front of the building; three on each side of the entrance. Atop the building was a dome. On the first floor of the two-story building were housed the treasurer, marshal, tax collector, fire department, and street department. The council chamber and the library were located on the second floor. The building was damaged by the 1933 earthquake and was condemned. It was demolished after World War II. (Courtesy of *Herald Examiner* Collection/Los Angeles Public Library.)

The Woods Mortuary, the first mortuary in Wilmington, was established in 1913 at 702 Broad Avenue. David Woods's first place of business was in a storeroom at Fries Avenue and Anaheim Boulevard. He paid a rental fee of $15 per month. At that time, the death rate was about 12 persons per year. Three of his siblings—Gertrude, Elizabeth, and Thelma—lived in the Banning Wrigley Historic District. Pictured is the building housing the distinctive funeral service.

In 1922, a group of yachtsmen founded the California Yacht Club (CYC) in Wilmington at Berths 193–194. Shortly afterward, in March 1923, architect Edwin Bergstrom designed and dedicated the clubhouse in time for summer sailing. By 1929, the CYC had advanced to first place among Pacific Coast yacht clubs with buildings, equipment, and mooring valued at more than a quarter of a million dollars and its club membership at approximately 1,200. The Hollywood elite, politicians, and famous athletes were no strangers to the CYC. During World War II, the U.S. Coast Guard took over the clubhouse for national security purposes. After the war, the yacht club was demolished and replaced by the Matson Terminal. (Courtesy of the M. Kashower Company.)

Walter Charles Richards purchased a small plot of land on A Street. A two-room shop was built to house his new business, named Wilmington Iron Works in honor of the company where Walter served his apprenticeship. On March 1, 1920, the doors officially opened. The company stayed in its original location for 10 years until moving to its present site on C Street in late 1930. The Richards families lived at 1214 and 1215 Banning Boulevard in the Banning Wrigley Historic District. (Courtesy of the Richards family.)

The SS *Catalina* was a million-dollar steamship in the days when $1 million was a lot of money. William Wrigley Jr. had it built and laid the keel himself on December 26, 1923. The SS *Catalina* transported passengers in a more elegant style from Wilmington to Santa Catalina Island. During her lifetime of 51 years, she carried 2.4 million passengers, and during her war service, she carried over 800,000 troops, more troops than any other army transport throughout the war. (Courtesy of Catalina Island Museum.)

On May 3, 1924, Marcia A. Patrick (at center stage carrying roses), daughter of Joseph Patrick, president of the Wilmington Transportation Company, christened the SS *Catalina* with 3,000 spectators cheering her on. Accompanying her from left to right are D. M. Renton, Mrs. D. M. Renton, L. E. Caverly, J. H. Patrick, and Thomas J. Farley. (Courtesy of Catalina Island Museum.)

Capt. Louis Black Sr. was outside manager for the Wilmington Transportation Company's big fleet of tugs. He was well known as a fine shipping navigator but a little rusty in his navigating of cars. In this photograph, he forgot to set the brakes on the company 1925 Model T Ford. This must have been a tough situation to explain. (Courtesy of Elizabeth Black.)

In 1929, the Ford Motor Company assembly plant, covering 40 acres, was under construction in the Cerritos Channel. Sixty-eight percent of the plant was in Wilmington and 32 percent in Long Beach. The stock market had just crashed and many wondered what Henry Ford was thinking. His response was that the crash was only temporary and besides, the plant was already under construction. The plant produced cars in Wilmington until 1959, when production was moved to Pico Rivera. Both Ford and Wrigley were driving forces in Wilmington's economy.

At any occasion when it could "best be said with flowers," Drew's Flower Shop was there. The shop was located at 732 Avalon Boulevard and sold the freshest flowers. Drew's stocked attractive vases, figurines, and all one's floral needs. Al Drew lived in the Banning Wrigley Historic District at 1234 Lakme Avenue. (Courtesy of Security Pacific Collection/Los Angeles Public Library.)

Wilmington Creamery's one-horse carriage is delivering milk to Phineas Banning High School. It was often seen making its deliveries on the streets of Wilmington. Delivery service like this was prevalent during the town's early years. The horse appears to be waiting patiently while the driver stops to pose for the photograph.

In 1929, architect Sid Spearin built the *Wilmington Press* building at 618 Avalon Boulevard. It later became the home of the *Wilmington Press-Journal*. Spearin was responsible for the selection of the Catalina tile used for the special architectural detail on the front of the building. Claude Preston (C. P.) Roberts launched the *Wilmington Press* in about 1929, publishing daily except Sunday. In the 1940s, the *Press* bought out the rival *Wilmington Journal* and became the *Press-Journal*. Three generations of the Roberts family worked there. Richard Roberts, son of C. P. Roberts, resides in the Banning Wrigley Historic District at 1258 Lakme Avenue.

Seen here in 1939, Sid Spearin attended the groundbreaking ceremony of the new Grand Central Market at 1467 Avalon Boulevard in Wilmington. Spearin was the architect and contractor for the Banning Wrigley Historic District. He was so pleased and impressed by the results of the neighborhood that he built his own Italianate-style home at 1237 Lakme Avenue at a cost of $8,350. Sid Spearin is fourth from the right. (Courtesy of Security Pacific Collection/Los Angeles Public Library.)

C. W. Post of the Post Cereal Company built the Granada Theater, located at 623 Avalon Boulevard, in 1926. The original decor was Spanish style. In plaster above the columns of the proscenium is the letter "P" for Post. The highlight of the Granada was the original advertising curtain with a central painting. It was a hand-painted wagon train surrounded by advertisements of 22 local businesses with their two-digit telephone numbers.

Thousands attended the grand opening of the Don Hotel, the finest hostelry near the Port of Los Angeles, on July 2, 1929. Mammoth searchlights and klieg lights cast pastel lighting on the building located at 105 East I Street. Their brilliance made the event the most distinctive opening ever held in Wilmington. Many movie stars and famous people stayed at the hotel in its heyday during the 1930s.

The present-day Don Kott Ford dealership began in Wilmington in 1930. Seen here as Kott and Smolar Motor Company at 336 West Anaheim Street, the dealership featured Ford, Falcon, and Thunderbird automobiles and Ford trucks. The firm also maintained a large used-car lot where they reconditioned vehicles of all makes and sold them at "attractive prices." Notice the brick architecture and the old streetlights.

It is now 1950, and the Kott dealership has a new look, name, and location. The Thunderbirds have arrived and are displayed for everyone to see. Not only has Karl Kott moved his business, but he has also purchased a charming Cape Cod home in the Banning Wrigley Historic District at 1257 Banning Boulevard. It is the former home of Clem Christie. With his home and business in the community, Kott is a prime example of the "Live and Work in Wilmington Club." Note how the streetscape has changed from the 1930s.

Like most towns and cities around America in 1938, Wilmington had a Western Union Office. It was located at 811 Avalon Boulevard. Agents John Millett and George Leks sent and received telegrams and sold money orders. Paul Sheppard was a page and made deliveries. Pictured are, from left to right, John Millett (manager), Paul Sheppard, and George Leks.

Wilmington's pioneer plumber, William B. "Bill" Oakes, was better known as "Your Plumber" and "A man of integrity since 1913." The firm carried a large line of gas appliances, which he proudly displayed at his store at 514 West Anaheim Street. Featured are Hoyt Water Heaters, Electrolux Gas Refrigerators and Gaffers, and Sattler Gas Ranges. (Courtesy of Security Pacific Collection/Los Angeles Public Library.)

The Rossman Brothers Lumber Company at 645 Lagoon Avenue was established in 1923. Two years later, they moved the business to a larger location at B Street and Bayview Avenue and changed the name to Rossman Mill and Lumber Company. Elmer J. Rossman served as president from 1928 until 1943. Elmer and Gertrude Rossman lived at 1244 Banning Boulevard in the Banning Wrigley Historic District from the 1930s to the 1960s.

After the consolidation of Wilmington and Los Angeles in 1909, the chamber changed its name to the Greater Los Angeles Harbor Chamber of Commerce. This caused an identity problem, and in 1923, the residents voted to change the name back to Wilmington Chamber of Commerce. The chamber office was located at 327 Avalon Boulevard from 1919 until 1954. Some chamber members pictured against the building are, from left to right, unidentified, Anna Hall, Howard Crandall, Walter Holstein, unidentified, and E. B. Kilstoffe.

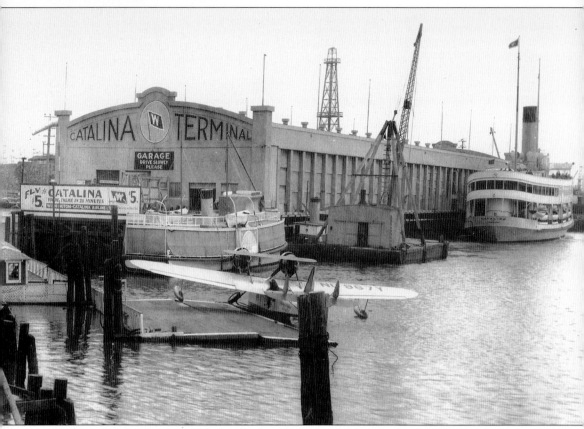

William Wrigley Jr. supported the development of Santa Catalina Island as a resort. In 1920, he began construction of the Catalina Terminal at Banning's Landing at the foot of Avalon Boulevard. Upon completion, it would be the future home of the Wilmington Transportation Company. The company with its four steamers—*Hermosa, Cabrillo, Avalon,* and SS *Catalina*—and Wilmington-Catalina Airline made it the gateway to Santa Catalina Island. The landing for the Douglas *Dolphin* can be seen in the foreground of this 1938 photograph of the Catalina Terminal building. The banner is advertising, "Fly to Catalina for $5.00." The SS *Catalina* can be seen docked in the background. (Courtesy of Port of Los Angeles.)

In 1931, Phillip Wrigley founded Wilmington-Catalina Airline. The airline consisted of twin-engine Dolphin amphibian planes, which flew from the docks of Wilmington to Santa Catalina Island. The March 1941 issue of *Flying and Popular Aviation* called Wilmington-Catalina Airline "the shortest airline in the world." The article pointed out that the airline served two towns less than 30 miles apart. They suspended service at the outbreak of World War II. (Courtesy of Port of Los Angeles.)

The Pacific Electric *Catalina Special* began passenger service in 1920, coinciding with the opening of the new Catalina Terminal. The *Catalina Special* was the most famous and heaviest traveled train on the entire Pacific Electric system. Daily the line took passengers to the Catalina Terminal from stations in downtown Los Angeles, Long Beach, and Pasadena. Hundreds of thousands of tourists were dropped off and picked up outside the ticket office of the Catalina Terminal. Note how the tourists are dressed. (Courtesy of Port of Los Angeles.)

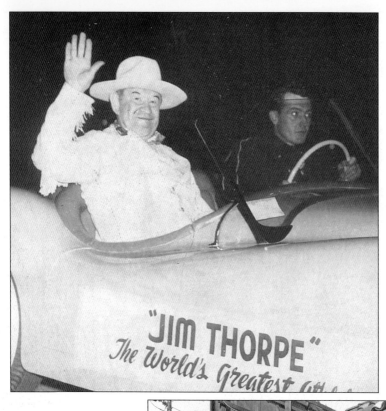

Jim Thorpe, the "World's Greatest Athlete," is seen in a Wilmington Fiesta parade. His Native American name was Wa-tho-huck ("Bright Path"). Thorpe was a Wilmington resident during the 1930s and 1940s. He managed the Wilmington Recreation Center at 219 East Anaheim Street. During World War II, Thorpe worked at the local Ford Motor Company plant. He died of a heart attack at the age of 66 in Lomita, California.

The Wilmington Recreation Center, located on East Anaheim Street, was a four-lane bowling alley managed by Jim Thorpe, the "World's Greatest Athlete." It provided part-time jobs for the local youth, setting and resetting bowling pins. Inside the bowling alley was Neal's Sandwich Shop, which sold ice cream, malts, and sundaes. The bowling center was the social gathering place enjoyed by just about everyone in Wilmington.

-:- Junior Chamber Display at 1934 Miami Convention -:-

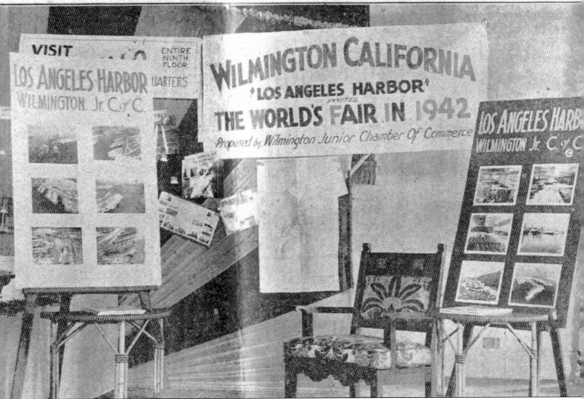

The Wilmington Junior Chamber of Commerce display at the Miami Chamber of Commerce Convention in 1934 proposed the Los Angeles Harbor as a site for the 1942 World's Fair to commemorate the 450th anniversary of the discovery of America and the 400th anniversary of the discovery of California. Harbor historian Thomas Keaveny believed it would be fitting for the celebration to depict four centuries of progress in the Los Angeles Harbor.

Seen here is Dr. R. W. Stellar's new state-of-the-art medical building at 1265 Avalon Boulevard, just three blocks away from where he lived at 1265 Banning Boulevard in the Banning Wrigley Historic District. He exemplified the motto of living and working in Wilmington. His stately two-story Colonial Revival home was the perfect place to raise his two sons, Tony and Allen. (Courtesy of Security Pacific Collection/Los Angeles Public Library.)

On August 9, 1923, the Beacon Drug Store had its grand opening. The site was originally called the Miller Building. An estimated 200 to 300 people attended the opening. A band was employed, and those who wished to dance did so on Anaheim Street during the evening's entertainment. According to the daily *Wilmington Journal*, the Beacon Drug Store gave away 100 boxes of candy and 700 ice cream cones.

The Wilmington Cab Company, established in 1923, was located in the Central Garage at 127 West B Street. Cabs worn out by heavy use during the war were replaced with a brand-new fleet as soon as the vehicles rolled off the assembly line. All the new taxis were "lemons," and the Wilmington Cab Company almost went broke repairing the vehicles. However, for the first time, the new cabs were equipped with two-way radios.

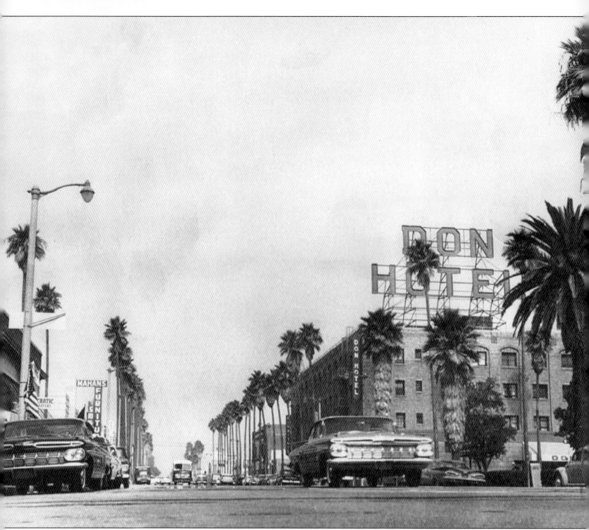

Millions who have visited Wilmington to board ships such as the SS *Catalina* know this view of Avalon Boulevard with the palm trees. Its original name was Canal Street. In 1919, William Wrigley bought Catalina Island from the Banning brothers, William, Joseph, and Hancock. Canal Street (Avalon Boulevard) became the gateway to Avalon Bay and Catalina Island. The Catalina terminal at the foot of Canal Street became the berth for the SS *Avalon* and the SS *Catalina*. In 1927, Wrigley was instrumental in changing the name of Canal Street to Avalon Boulevard after the SS *Avalon*. The Don Hotel seen in the photograph was a destination for the Hollywood and political elite in the 1930s. (Courtesy of *Herald-Examiner* Collection/Los Angeles Public Library.)

Four

BANNING WRIGLEY HISTORIC DISTRICT

William Wrigley Jr. with his horse "Bingo"

More than 150 years have passed with many startling changes since Phineas Banning last saw San Pedro Bay and the city of Wilmington. Where Banning's vision ended, William Wrigley's began. Wrigley started with the purchase of Catalina Island in 1919 from the Banning sons William, Joseph, and Hancock with plans to develop it into a first-class resort and make Wilmington a close rival of New York City. In 1927, Wrigley and Henry Ford of the Ford Motor Company invested $1 million each into Wilmington's future, which led to Wrigley's formation of the Fleming and Weber Company. One of the company's tasks was to develop the "Original Court of Nations," a development of 100 custom homes, which became the Banning Wrigley Historic District (Banning Park HPOZ). Entering the 21st century, the current preservationists of the neighborhood have continued to carry on the vision of their forefathers by advocating the designation of a City of Los Angeles Historic Preservation Overlay Zone. In July 2001, due to their success in achieving this landmark status, their vision will continue for future generations. (Courtesy of Catalina Island Museum.)

With the passing of Phineas Banning in 1885, a pioneer whose foresight and energy helped to develop this great country, he left behind the Banning mansion overlooking the grounds he so carefully planned and developed. Banning's characteristics of energy and fortitude continued in other members of the family and led to the preservation of his home. The estate was left to Hancock Banning until his death in 1925. Since 1927, Banning House and about 20 acres have been part of the Los Angeles park systems due to the efforts of Hancock Banning's wife, Anne.

Because of the many years General Banning spent making the grounds beautiful and the many rare shrubs and trees he had brought from around the world, she felt it should be preserved and protected as a park. In 1927, the Fleming and Weber Company bought the remainder of the Banning estate for its location and beauty to develop the "Original Court of Nations," known today as the Banning Wrigley Historic District. (Courtesy of Works Projects Administration/Los Angeles Public Library.)

This street scene of Lakme Avenue at M Street, looking south, depicts the first of four blocks developed by William Wrigley Jr. in the Banning Wrigley neighborhood. Architect Sid Spearin named the tract the Original Court of Nations, intended to represent an assortment of period revival styles from around the world. Lakme Avenue is named after Leo Delibe's opera *Lakme* and the SS *Lakme*.

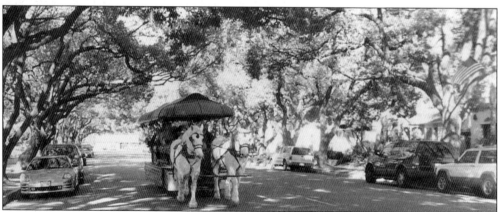

Eighty years later, looking down Lakme Avenue to M Street, the beautiful camphor tree–lined street is the signature of the Banning Wrigley neighborhood. The camphor trees are historical landmarks designated as Los Angeles Cultural Monument No. 509. The horse-drawn carriage is a common sight during the annual Victorian Christmas activities for the Banning residence, Drum Barracks Museum, and the Banning Wrigley Historic District. (Courtesy of Simie Seaman.)

Arthur and Pauline Black made a dashing couple. Pauline was a popular member of the social set of Los Angeles, and Arthur was the second mate of the *City of Los Angeles*, which plied the waters between San Pedro and Honolulu. Arthur was the son of Capt. Louis Black, port captain of the Wilmington Transportation Company. Arthur and Pauline purchased the home at 1244 Lakme Avenue and moved in August 15, 1927. (Courtesy of Elizabeth Black.)

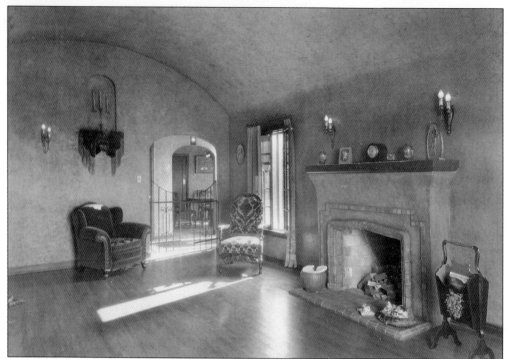

Seen here in the living room of Capt. Arthur Black, the barrel-vaulted ceiling, wooden floors, archways, and wall sconces are just some of the wonderful architectural features. Architect Sid Spearin took a personal interest in making all homes that he built of the finest quality, making each a treasure to own. (Courtesy of Elizabeth Black.)

This wonderful 1927 Spanish Colonial Revival, built by the Fleming and Weber Company for Capt. Arthur Black and his wife, Pauline, provided additional living space in the courtyard and an excellent view of the neighborhood. (Courtesy of Elizabeth Black.)

For many youngsters, home life in the Banning Wrigley District meant having horses. Horses were owned by the Denni, Merkley, Morris, and Richards families and were kept in the neighborhood up until the 1950s. Pictured in a 1936 photograph, Robert Denni ("Bob") is holding Babe with his two sisters, Elinor (left) and Elisa, mounted on the horse. Their father, Joseph, rode for the Los Angeles County Sheriff's Mounted Posse. (Courtesy of Elisa Denni Bagdasar.)

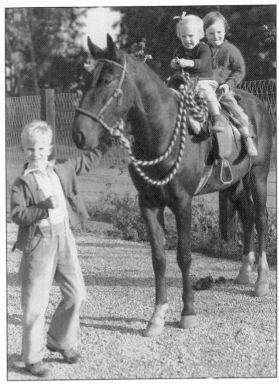

What family has not taken a picture in the backyard? Seen here are the Roberts siblings with their maternal grandfather, "Granddaddy" Warren S. Pangborn. Pictured are, from left to right, Richard, Robert ("Bob") with holster, riding boots, and hat, and the oldest, Marilyn Jean. (Courtesy of Richard Roberts.)

The Banning Boulevard cowboys were a frequent sight in the neighborhood. Rich Richards, in his cuffed jeans and hat, proudly displays his rifle. His close friend Chuck shows off his white holster and scarf, while his friends Sissy and Mike have on clothing of the era—girls in dresses and boys in cowboy shirts. In the background, notice the wide, tree-lined street. (Courtesy of the Richards family.)

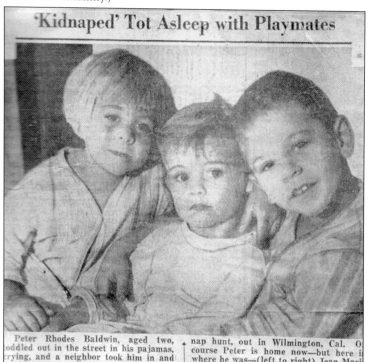

'Kidnaped' Tot Asleep with Playmates

Peter Rhodes Baldwin, aged two, toddled out in the street in his pajamas, crying, and a neighbor took him in and put him to bed with his two children. And then—there was the hue and cry of a kid- nap hunt, out in Wilmington, Cal. Of course Peter is home now—but here is where he was—(left to right) Jean Marie Nerad, 5; Peter, and John Russell Nerad 7. Picture from International News

Dr. Anton Nerad was always on duty at home or at the office. Under his watchful eye, a wandering Peter Baldwin was rescued and returned home safely. It was just another day in the life of Doctor Nerad. (Courtesy of Dr. John Nerad.)

Gathering and playing in the backyard was a common experience for these neighborhood children on Banning Boulevard. Seen in this July 20, 1941, photograph are, from left to right, Virginia, William, and Donald Kimble, the children of Orva and Helen Kimble. Orva was a superintendent at the local Texaco refinery. The family lived in company housing before moving to 1237 Banning Boulevard in 1933. Helen was active in the local women's club. (Courtesy of William "Bill" Kimble.)

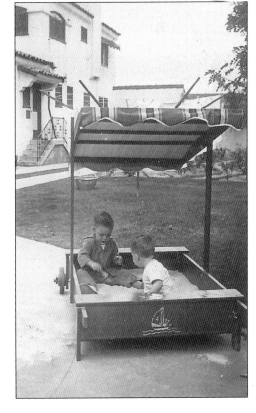

At play in the backyard sandbox of the Richards home are W. C. ("Rich") Richards (left), wearing the sailor outfit, and his cousin Ed. Note the little sailboat insignia on the side of the sandbox. W. C. grew up to be quite the sailboat enthusiast. (Courtesy of the Richards family.)

The Roberts and Pangborn families seen here at 1258 Lakme Avenue were all Wilmington residents at one time. Preston Roberts was publisher of the *Wilmington Press-Journal*. Gordon Cline, a contractor, worked on the Vincent Thomas Bridge. From left to right are (first row) Lois (Pangborn) Roberts, Kristi Lofthus, Marilyn Roberts, and Laura Pangborn; (second row) William Pangborn, Gladys Pangborn, Preston Roberts, W. S. Pangborn, Gordon Cline, Sylvia Cline, unidentified, Lucille (Pangborn) Cline, Dick Lofthus, and Richard Roberts. (Courtesy of Richard Roberts.)

At their home, Bobbie and Sue Miller (standing right) are sharing their new baby daughter, Cynthia, with her maternal grandparents, Louie Allen and Beulah Miller. Standing behind them are the Millers' daughter Wynona Morrison (left) and granddaughter Johnnie Sue Morrison (right). In 1972, Bobbie and Sue purchased the Spanish Colonial Revival jewel at 1251 Banning Boulevard, which would later be featured in major magazines. (Courtesy of the Miller family.)

The Denni family was among Wilmington's early pioneers. Joseph Denni was president of Wilmington Savings and Loan Association and the Denni Corporation, a director of the chamber of commerce, a charter member of Native Sons of the Golden West, a life member of BPOE (Benevolent and Protective Order of Elks) San Pedro Lodge 966, and a member of the SS. Peter and Paul Church and Harbor Area Boy Scouts. Joseph rode for the Santa Barbara Rancheros, the famed Los Angeles Sheriff's Posse. Grace Denni identified herself with philanthropic and cultural endeavors, including the American Red Cross, the San Pedro Philharmonic, Artists Association, and San Pedro Assistance League. Denni Street is named after this family. (Courtesy of Elisa Denni Bagdasar.)

Joseph and Grace Denni's living room at 1285 Lakme Avenue is the perfect setting for the Louis Denni family portrait. From left to right are (seated) Louis Denni, Robert Denni, Sr. Mary Bonaventure (Denni), and Elisa Denni; (standing) Emil Neuman, Elizabeth (Denni) Neuman, Louis Neuman, Francis Neuman, Grace Denni, and Joseph Denni. (Courtesy of Elisa Denni Bagdasar.)

The happy, smiling couple in the lush backyard of their 1262 Lakme Avenue home is Glenn and Evelyn Merkley. They met at the Calvary Presbyterian Church in Wilmington. Glenn worked for National Supply Company in Torrance as the works manager, and Evelyn worked as a secretary for John B. Chadwick. Evelyn's grandparents, the McClellands, lived down the street at 1228 Lakme Avenue. It was a common occurrence in the Banning Wrigley Historic District to have relatives living nearby. (Courtesy of Marilyn Merkley Turner.)

Horses were no strangers to the neighborhood. Both youngsters and adults had their own. At left is Evelyn (McClelland) Merkley riding Wilson's Black Magic in front of her home (above). Black Magic was a Tennessee Walking Horse whose lineage went back four times to Allan F-l, the foundation stallion for all Tennessee Walkers. In the middle is Earl Foster on Rex, an American Saddlebred. At right is Helen (McClelland) Foster on Dixie, an Arab and quarter mix. (Courtesy of Marilyn Merkley Turner.)

The Capolungo family is a traditional family of the Banning Wrigley historic neighborhood in the late 1940s when family gatherings were an important part of life. The Capolungos shared many holidays, birthdays, and anniversaries. One of their favorite pastimes was to play canasta with the Blacks. Pictured from left to right are Arthur Black, Virginia Capolungo, Paul Capolungo, and Pauline Black. (Courtesy of Paul Capolungo.)

Sid Spearin of the Fleming and Weber Company designed this attractive Spanish Colonial Revival in 1927 for Paul and Petrina Capolungo. Architect and contractor Sid Spearin designed homes of high quality with the accent on casual living. Patios, yards, and barbecues were commonplace. During the construction phase of the Banning Wrigley District, William Wrigley and his wife, Ada, would tour the homes. The Capolungo family lived here until 1975. Jack and Connie Rubio are the current owners. (Courtesy of Paul Capolungo.)

Seen in this c. 1950 photograph, Florence Driscoll is on her way to church. She is the widow of Louis Driscoll. She is wearing the fashion of the day: hat, gloves, and purse. Louis was an employee of Metropolitan Insurance Company who in earlier times traversed his territory on a bicycle collecting insurance premiums. Together they built the house at 1233 Lakme Avenue. They spent many evenings with the Capolungo family. (Courtesy of Paul Capolungo.)

Mildred Shuey is showing off her new dress for the Fries Avenue Elementary School PTA Founders Day. She was honored for her service as president. Everyone admired Mildred's devotion to the ideals of parenthood and her untiring efforts on behalf of the children of Fries Avenue. In 1951, Mildred and her husband, Howard, built their home at 1209 Cary Avenue, where they lived for the remainder of their lives.

Is this a Hollywood set or Wilmington? The picture captures Elva (Oakes) Richards, first queen of the Wilmington Historical Pageant and Fiesta, waving from her 1940s Packard as she enters the arches of their Spanish Colonial Revival home at 1215 Banning Boulevard. The Richards family also owned the Tudor Revival across the street at 1214 Banning Boulevard. The family had strong ties to Wilmington; it was a great place to live, work, and play. (Courtesy of the Richards family.)

A well-known local doctor, Dr. Turner Burton Smith Sr. resided at 1222 Avalon Boulevard. This Dutch Colonial Revival–style structure has provided a lifetime of comfort with character. Seen here in 1945, the Smith family is arriving for a Sunday garden party. The family's La Salle and Cadillac are parked in front. In the 1950s, the home was moved to the Banning Wrigley Historic District at 406 East M Street. (Courtesy of the Smith family.)

Seen here in 1945 are Dr. and Mrs. Turner Burton Smith Jr. in the garden of their family home with their first child, Deanne. Dr. Smith was the personal physician to Ronald Reagan and served as physician to the president during Reagan's second term in office, from 1985 to 1987. Deanne Smith, now Judge Deanne Smith Myers, is a judge of the Los Angeles Superior Court in Long Beach. (Courtesy of the Smith family.)

Marilyn Merkley is seated at bottom left in a presentation picture for Kappa Kappa Gamma at the University of Southern California in 1949. She went on to become president of the chapter as well as president of Spurs, a sophomore service organization, and a member of Amazons, a junior-senior service organization for USC. (Courtesy of Marilyn Merkley Tuner.)

The Banning Wrigley neighborhood made the perfect setting for a wedding picture. Seen here, Efren and Elisa Quintana are celebrating their daughter Rita's wedding in the front yard of their home at 1228 Lakme Avenue. The Quintanas in the 1970s owned the Topper Steak restaurant on Pacific Coast Highway in Wilmington. These longtime residents believe in preserving the neighborhood's history and have done so by retaining the historic character of their home. (Courtesy of the Quintana family.)

Pictured here are Jose and Rosalina Arroyo, longtime preservationists and activists for the Banning Wrigley Historic District. In 2001, all their hard work and dedication paid off. The City of Los Angeles designated the neighborhood a Historic Preservation Overlay Zone and appointed Jose to the HPOZ Board to help oversee the district. When in Wilmington, you can find them restoring their American Colonial home at 402 East M Street. Jose and Rosalina have residents' sincerest and deepest thanks for being the caretakers of the neighborhood's history. (Courtesy of the Arroyo family.)

In 1923, this fine example of an American Colonial home at 402 East M Street stood adjacent to the Banning residence on the grounds of the Banning estate; the area that later would be designated as the Banning Wrigley Historic District. The home has been featured in several movies over the years. Leonard Sly, better known as Roy Rogers, lived here for several years. Preservationists Jose and Rosalina Arroyo currently live in the home. (Courtesy of the Arroyo family.)

In 2002, the Los Angeles Conservancy sponsored the first annual Historic Preservation Overlay Zone Tour. The Banning Wrigley Historic District was a featured district. The Spanish Colonial Revival home in the center was showcased. Built at 1217 Lakme Avenue for Gertrude and Elizabeth Woods of the Woods Mortuary, this was the first home built by William Wrigley Jr. When it was under construction, Wrigley and his wife, Ada, would do inspections to make sure all was of the highest quality. Current owners Robert and Simie Seaman conduct private group tours of the home and historic district. (Courtesy of the Los Angeles Conservancy.)

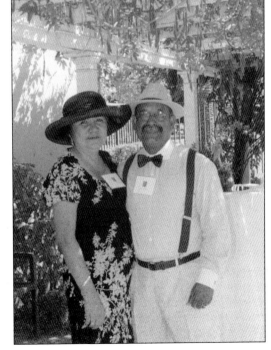

Arturo and Arcelia Saldana purchased the Dr. W. W. Horst home at 1254 Banning Boulevard in the Banning Wrigley Historic District because of its historic protection and beauty. They have invested numerous hours of labor and love into restoring their English Tudor Revival home. Here they are being recognized for their participation in the "An Afternoon of Elegance" progressive dinner home tour.

The Banning Wrigley neighborhood is proud of the young men who served our country during World War II. Pvt. Frank R. Villegas, left, and Pvt. Efren R. Quintana were members of the 2523rd Ordnance Medium Automotive Maintenance Company. They serviced all types of vehicles for the 82nd and 101st Airborne Divisions. This photograph was taken in France, sent to Quintana's mother from her son with all his love, and signed Efren. (Courtesy of the Quintana family.)

Home on leave from the U.S. Navy, John Nerad spent time with his family in the front yard of their home at 1202 Lakme Avenue. Pictured from left to right are John, Jean, Florence (John's sister), and Dr. Anton Nerad. The Nerad family was very civic minded. Dr. Nerad was president of the Rotary Club, and his wife, Jean, was president of the Wilmington Women's Club. She also was a retired schoolteacher. (Courtesy of Dr. John Nerad.)

Five

SCHOOLS

This two-story, wood-frame, four-room schoolhouse was Wilmington's first school, built in 1865. It sat in the middle of one city block of West G Street. John Downey, who was one of the original purchasers of Wilmington in 1854, donated the property for the school. This schoolhouse was demolished at the completion of Wilmington High School in 1912.

In 1912, Wilmington High School was built on the west corner of Anaheim Street facing Avalon Boulevard; it replaced the old wooden Wilmington Schoolhouse on Canal Street, now Avalon Boulevard. This stately structure had two stories of classrooms, and all 12 grades attended school in the building, making the name misleading. Because of its age, after the 1933 earthquake, the brick structure was almost abandoned. Surplus army tents and barracks were moved onto the grounds and used as classrooms. It is believed the school was demolished during World War II.

Seen here in a Wilmington High School junior class picture in 1919, two of the seven students would become prominent in the Banning Wrigley History District. In the back row, third from the left, is Glenn Merkley, and in the back row at far right is Ana Cary. Cary Avenue was named in honor of Ana's father, Fredrick Cary. Glenn resided at 1262 Lakme Avenue.

Six years before this photograph was taken in 1923, this northwest corner of Wilmington High School grounds was a patch of weeds. Because of the efforts of J. M. Hart, it developed into one of the most beautiful spots in Wilmington, a corner that was attractive to all, whether newcomers, old residents, or tourists. He believed beauty is not only developed through flowers but by the systematic and careful planting of seeds so that the vegetables, as they grow, are an attraction. The agriculture department of the school was far-reaching. Each season, thousands of plants were distributed for home gardens. The annual Home Garden Contest helped stimulate community pride, and its value was proven by the number of prizes voluntarily given by the various business interests of the community.

Phineas Banning High School, originally known as Wilmington High School, was located at the corner of Anaheim Street and Avalon Boulevard. Banning High School was renamed in honor of General Banning in 1926. Its new location at 1500 Avalon Boulevard was completed in January 1926 at the cost of $385,000. A fine library, large auditorium, and separate shop building were among the advantages at this new school. The stately red-brick building was a landmark in the community for many years. The ivy-covered building suffered damage in the 1933 and 1971 earthquakes. It was a sad time for Wilmington when they saw the school that had come to represent so much to the community demolished in 1972. For three years, classes were held in bungalows while the new building was under construction. In the fall of 1975, the new facility was opened with a new gym and swimming pool.

Banning High School coach Pete Zamperini instructs three of his football players. Zamperini had a long successful career at Banning. He coached track and field from 1947 through 1977. Before starting his coaching, Pete trained his younger brother, the great Lou Zamperini of Torrance High School, to a place on the 1936 U.S. Olympic Team in the 5,000-meter run.

In 1942, Coach Mark Sampson led the Banning High School B junior varsity basketball team to a championship victory with the help of his "gold dust twin" forwards (first row center), Ralph Violante (25) and Efren Quintana (26). After graduating, Quintana joined the army to serve his country in World War II. In the early 1960s, he purchased a Spanish Colonial Revival home in the Banning Wrigley Historic District and still resides at 1228 Lakme Avenue. (Courtesy of the Quintana family.)

Jersey No. 27, going for the ball, is Don Kott. He received the Banning High 1949 Sportsmanship Trophy while playing on the varsity basketball team with his teammate and neighbor, Alan Stellar. Don is the son of Karl Kott of Kott Ford Company, known today as Don Kott Ford. Alan is the son of Dr. R. W. Stellar. Both Kott and Stellar lived on Banning Boulevard in the Banning Wrigley Historic District.

Shown in this Banning High 1949 junior varsity baseball team photograph are (first row, sixth from left) Robert "Bobbie" Miller and (second row, far right) Coach Vincent Carrese. Bobbie Miller was an excellent ball player and was sought out by a Los Angeles Major League team to play shortstop. In 1972, Bobbie and Sue Miller moved into the Banning Wrigley Historic District, where they raised their two children, Cynthia and Mark.

In 1951, Maria Dolores Dominguez De Watson donated $60,000 to build SS. Peter and Paul School. Fr. John Dunne had an eight-room school with an auditorium built at the site of the old SS. Peter and Paul Church on Anaheim Street, and it is still located there today. That same year, the Sisters of St. Joseph of Cluny arrived to staff the new school.

This 1945 photograph records the SS. Peter and Paul new parish school's first eighth-grade graduating class. From left to right are (first row) Robert Trujillo, Bill Collins, Donald Drew, Shirley Allen, Bonita Sexton, Joan Marie Cornel, Margaret Hilfill, and Rachel Urrea; (second row) Bill Page, Neil Hope, Edward Nagel, Paul Capolungo, Rev. John V. Hegarty, Bernardine Flynn, Josaline Hilton, and Patricia Kelly. Capolungo, Drew, and Trujillo lived in the Banning Wrigley Historic District. (Courtesy of Paul Capolungo.)

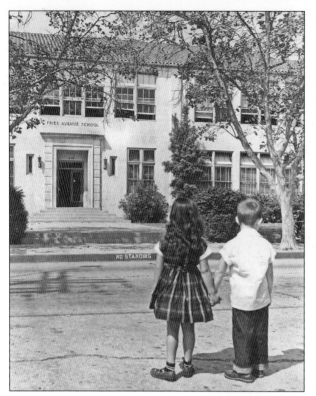

On the first day of school, these two unidentified grade-school friends hold hands in front of Fries Avenue Elementary School. The school was built in 1923 and is one of Wilmington's oldest elementary schools. The kindergarten grades were added in 1961 and the cafeteria in 1977. The school originally served grades one through 12. The school and the street where it is located are named after Amos Alfred Fries, a military captain who came to Wilmington in 1906 to redesign and lengthen the breakwater of the Los Angeles Harbor. Both Vince Ferragamo and Daniel Reece are former students, professional football players, and successful businessmen who attended Fries Avenue School.

A "Healthful Breakfast" was part of Nikki Guidinger's third-grade class health and nutrition program. Students planned, purchased, prepared, served, and cleaned up the "Healthful Breakfast" for their parents and invited guests. Pictured are June Munce (second from the left), Nikki Guidinger (center), and Dennis Solomon (sixth from the right). Guidinger had a special talent for keeping her students motivated, and the students loved her for it.

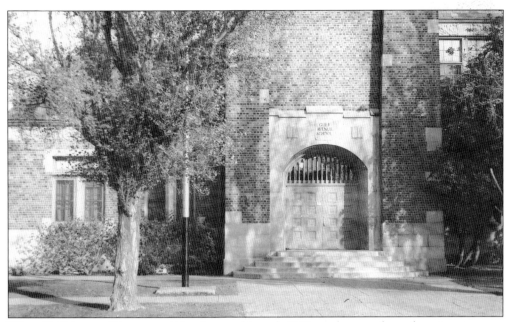

When Gulf Avenue Elementary School opened in early 1924, teachers taught students in temporary housing. In April of the same year, Fries Avenue Elementary School transferred two bungalows and a tent to the school to help with the overcrowding conditions. This enabled all but one class to attend full time. In September 1926, the 291 students who had been attending classes in bungalows were moved into this beautiful new two-story brick building.

The boys in John Nerad's 1932 first-grade class at Gulf Avenue School wore a wide array of dress, from shorts to overalls to white shirt and tie. The boy in the white shirt, at left in the second row, grew up to be Dr. John Russell Nerad. John's father was Dr. Anton H. Nerad, who had a practice above the Beacon Drug Store on Avalon Boulevard. The Nerad family lived in the Banning Wrigley Historic District at 1202 Lakme Avenue. (Courtesy of Dr. John Nerad.)

This Holy Family Grammar School first-grade class of 1983 celebrates Christmas. Behind the children, one can see the decorations they had made. From left to right are (first row) Eva Alvarez, Cindy Ortiz, Kathy Rivas, Brandee Diaz, Lucy Solache, and Rosemary Diaz; (second row) Sister Teresita, Yesnia Villegas, Veronica Vargas, Marcie Mora, Stephanie Preciado, Irene Anaya, and Vanessa Vargas. Vanessa Vargas lived several blocks away at 1262 Lakme Avenue in the Banning Wrigley Historic District. (Courtesy of Joe and Gloria Vargas.)

In early 1950, Holy Family Grammar School was built on nine lots at the cost of $8,758. The school contained nine classrooms, two offices, a facility room, a nurse's office, and a double-size room that in time became the library. It was the first parochial school to be conducted in the Archdiocese of Los Angeles by Carmelite Sisters of the Sacred Heart. The first principal of Holy Family Grammar School was Sister Josephine. The enrollment in 1950 was 235 in five grades.

Seen here on November 15, 1945, are Hawaiian Avenue Elementary School students demonstrating their patriotism through their purchase of an ambulance, which they paid for by selling war bonds and holding a stamp drive. (Courtesy of the National Archives, Pacific Region, Laguna Niguel.)

On November 15, 1942, Hawaiian Avenue Elementary School opened in army surplus buildings adjacent to Dana Strand Village, with eight classrooms and 10 teachers. This new structure in 1949, still being used today, replaced the army buildings.

The currently named Wilmington Middle School started out as Coast Boulevard Junior High School with about 400 students on April 27, 1949. By August of the same year, the name was changed to Wilmington Junior High School. The students were housed in temporary bungalows until the $1.5-million building shown here was completed and opened its doors for the first time on January 3, 1951. The building located at 1700 Gulf Avenue is still in use today.

Los Angeles Harbor Junior College, now Los Angeles Harbor College, was dedicated on October 28, 1949, on a 37-acre campus, with an enrollment of about 400 and a staff of 41. At that time, it was the fourth largest of nine junior college districts in the United States. The library was the finest and most modern among all California junior colleges. A part of the library was set aside for the perusal and study of local historic memorabilia and pictures, which the late librarian, Camille Baxter, was instrumental in collecting and preserving. It was the largest collection of its kind in Southern California. (Courtesy of Los Angeles Harbor College.)

Six

CHURCHES

The Salvation Army opened in Wilmington sometime between April 1924 and October 1925 at 602 Broad Avenue. The local church, known as a corps, served here until 1953. The Wilmington Salvation Army Corps Band would minister the word of God through its music at civic events and its own church services on Sundays. Third from the right is Adjutant Nock, holding the Bible under his arm. He served as the corps officer from 1925 to 1943.

Fr. Bernardino J. Schiaparelli was appointed pastor at SS. Peter and Paul in 1922 and became known for his role in building the new church. When he arrived, the parish consisted of a 57-year-old wooden church, a rectory, and a hall built in the 1880s. In 1927, plans for a new church began along with a campaign to raise money. The raising of the money to build the church was a personal triumph for Father Schiaparelli as he personally called on the Watson, Hancock, Denni, and Nesa-Canepa families and they responded generously. One of his fund-raising tactics was to sell self-portraits for $100 each. Monsignor Schiaparelli died on July 31, 1945, in the Mary Knoll Sisters Sanitarium in Monrovia, after a three-year illness.

SS. Peter and Paul Church was established in 1865, and Fr. A. Ubach was its first pastor. He was called "the last of the Spanish padres." The church was built at Neptune Avenue and Anaheim Street. It was the first parish church in Southern California, established shortly after the close of the romantic mission era of California. It is the oldest parish in the Southwestern District and the second-oldest parish in the Roman Catholic Archdiocese of Los Angeles.

In 1927, Father Schiaparelli designed the new SS. Peter and Paul Church after a church in his native village in Italy. The architecture is Italian Romanesque. A special feature of the church is the symbolism of the stone figures cast into the walls. The design of the inside of the church reaches its most inspirational expression in the magnificent baldachino (high stone canopy) supported by six concrete columns. The official dedication of the church was on March 25, 1931.

Joseph and Grace Denni's storybook wedding took place at the rectory of SS. Peter and Paul Church on September 26, 1926. Joe was an officer and Grace a secretary at the Wilmington Mutual Savings and Loan. They met at work and fell in love. In 1930, they built a Spanish Colonial Revival home at 1258 Lakme Avenue in the Banning Wrigley Historic District and started a family. They had three wonderful children: Bob, Elisa, and Elinor. In 1933, Joseph became president of the Wilmington Mutual Savings and Loan and the Denni Corporation. Retaining his early interest in ranching, he would ride annually in the Santa Barbara Rancheros Days event as a member of the Los Angeles County Sheriff's Mounted Posse. Denni was also a licensed pilot, had his own airplane, and flew with the Aero Squadron of the Los Angeles County Sheriff's Department. (Courtesy of Elisa Denni Bagdasar.)

Visitors at the Phineas Banning Museum in Wilmington often ask about the religious life of the Banning family. Phineas and his family were Episcopalians, and they founded St. John's Episcopal Church in 1882. It is the oldest church in continuous service in the harbor area. In 1882, under the supervision of their pastor, the Reverend Carlos Linsley, volunteers at the site on Canal Street (Avalon Boulevard) built the church. The Bannings paid the major cost of the building materials. In 1943, the church was moved to its present location at 1537 Neptune Avenue in Wilmington. There are several antique stained-glass windows in the church, one of them in memory of General Banning. The bell in the cupola is from the SS *Cricket*, an early side-wheeler that Banning used both in local waters and for trips to Catalina Island. The altarpiece is a fine specimen of Catalina marble, which the Bannings donated in 1925. St. John's is a modest, stave-type church of Colonial architecture. The church has been designated Historic Cultural Monument No. 47 by the Cultural Heritage Board of Los Angeles. The church is still very active, and the pastor administers Holy Communion every Sunday. (Courtesy of Banning Residence Museum.)

By fulfilling the spiritual and social needs of the community, which had no physical boundaries, Holy Family Church rode the crest of Wilmington and the area's tremendous growth. By 1964, there was so much activity in the parish that a hall was badly needed. In 1965, the Richard Moore Construction Company built the new parish hall seen on the right and the Right Reverend Monsignor Michael Sheahan dedicated it.

During the summer of 1928, the Catholic Action Clubs organized a Parish Picnic at Sycamore Park in Los Angeles. Plans for the first parish mass were formulated at this picnic, and the history of Holy Family Church began. These men, together with the Guadalupanas, were the original founders of the church. Pictured here are Nacho Munoz (second row, second from the left), Jose Trinidad Arroyo (second row, third from the left), Fr. Manuel Canseco (second row, fifth from the right), and Luz Arroyo (to the right of Canseco). Luz's nephew Jose G. Arroyo and his family reside at 402 East M Street in the Banning Wrigley Historic District. (Courtesy of Jose Arroyo.)

The first wedding at Holy Family Church took place on May 19, 1929; the couple was Ignacio Garibay and Consuelo Garcia. They were married by Fr. Luciano Gonzalez and entered into the Christian family of the new parish. They were active members in the church and helped celebrate the Holy Family Church 50th anniversary in 1978.

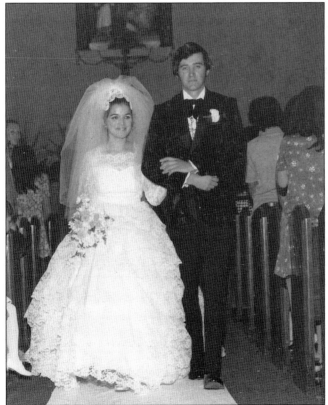

The 1973 wedding of Joseph Tobias and Gloria Dauz Vargas took place at Holy Family Catholic Church. The wedding reception for over 200 guests took place at La Union Mutualista De San Jose, one of the oldest social halls in Wilmington. Shortly after their marriage, they purchased a charming Spanish Colonial Revival home at 1262 Lakme in the Banning Wrigley Historic District, where they raised their family and still reside. (Courtesy of Joe and Gloria Vargas.)

Calvary Presbyterian Church has the longest continuous ministry among the 205 churches in the presbytery of Los Angeles. Soon after Rev. Herbert W. Tweedie's arrival, the new church was completed and dedicated on November 24, 1929. Without question, it was the most splendid house of worship in the harbor area. The church was a place of worship for many of the Banning Wrigley Historic District families. (Courtesy of Calvary Presbyterian Church.)

Memory Chapel was the first home of Calvary Presbyterian Church. It is the little white structure located next to the present church building on the corner of Marine Avenue and L Street. It was built in 1870 from lumber shipped around Cape Horn from the East Coast at a cost of $2,200. Thus a historical shrine significant in the early religious life in the harbor was created, and it played an important role in the history and development of the community. Designated City of Los Angeles Historic Cultural Monument No. 155, it is still used regularly for church services. (Courtesy of Calvary Presbyterian Church.)

Seven

PORT OF EMBARKATION

Few would disagree that soldiers were the most important supply that moved through the port. The first troop ship debarked from the Port of Embarkation on January 20, 1943. It is estimated that by 1945, a total of 213,474 army and navy personnel made their way on ships leaving the port bound for Indochina, China, Burma, and the Central and Southwest Pacific Theater of Operation. The men gathered here are receiving their three-day passes. (Courtesy of National Archives, Pacific Region, Laguna Niguel.)

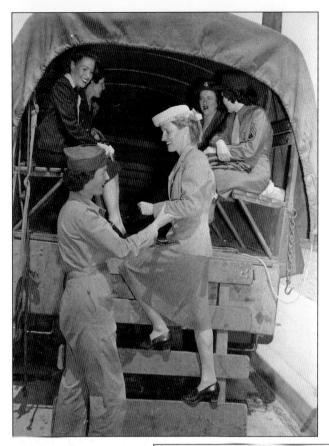

The Women's Army Corps (WACS) participated fully in camp life, playing softball, attending dances, and supporting the recruitment efforts of the public relations staff. The port commander recalled in his 1943 annual report that WACS were allowed to wear the insignia of the Transportation Corps. Seen here is Pvt. D. Smith assisting a newspaperwoman in the GI truck while on a tour of the port area. (Courtesy of National Archives, Pacific Region, Laguna Niguel.)

The military personnel were the most important supply that moved through the port. In 1944, these two enlisted men of the 874th Company are waiting to receive their three-day passes. By September 1945, there were 4,521 military personnel at the Port of Embarkation helping to load 9,018,301 tons of material on the ships and transport it to the army waiting across the Pacific Ocean. (Courtesy of National Archives, Pacific Region, Laguna Niguel.)

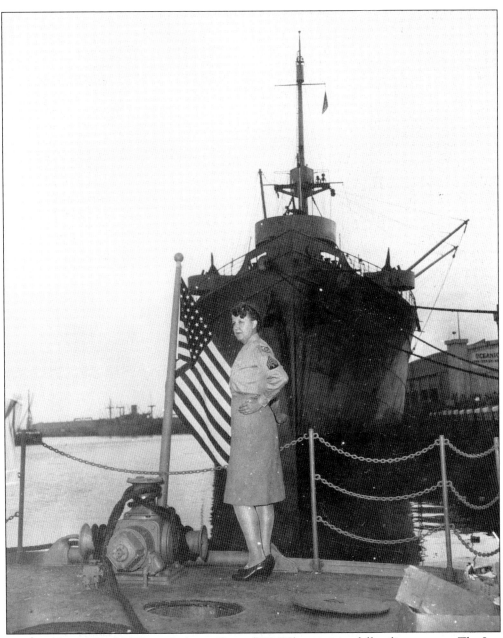

In November 1943, the Women's Army Corps (WACS) was given full military status. The Los Angeles Port of Embarkation at Wilmington received the first company of WACS to serve within the ranks of the U.S. Army in Southern California. The additional 6,500 members in the WACS would be about the same number in strength as Gen. George Patton's famous Seventh Army. (Courtesy of National Archives, Pacific Region, Laguna Niguel.)

On February 9, 1943, a great Liberty ship bearing the name of Phineas Banning was launched not far from the spot where he founded Wilmington in October 1858. Later this freighter, proudly flying the Stars and Stripes the general had loved so well, sailed away to carry supplies to men fighting in World War II. This would have greatly pleased the man, who all his life was known for his devotion to his country. (Courtesy of Banning Residence Museum.)

On April 1, 1944, the community military personnel of the Los Angeles Port of Embarkation and members of the U.S. Coast Guard unit at Wilmington conducted an Easter sunrise service on the front porch of the Banning Residence Museum at Banning Park, 401 East M Street. Port chaplain David C. Colony delivered the sermon, and Coast Guard chaplain M. L. Cook gave the invocation. (Courtesy of National Archives, Pacific Region, Laguna Niguel.)

On January 16, 1942, Banning Park became known as Camp Banning. The federal government took over nine and a half acres of Banning Park property, including the house and barn, to use as a Military Defense Area. During the war, several different regiments were stationed there. Barracks were built diagonally between the trees along M Street. After the war, the military barracks were used as emergency housing for veterans with families. In 1949, the Department of Recreation and Parks refused to renew the housing lease after a storm of controversy arose over the continued use of historic Banning Park for the project and the grounds were returned to their natural beauty. (Courtesy of Banning Residence Museum.)

The Wilmington Victory House was furnished by the Wilmington American Legion Post 287 and was brought out for every bond-selling occasion. Both Wilmington newspapers donated large two-page advertisements for the entire month of January 1943, urging the folks in Wilmington to raise $300,000 toward the purchase of a bomber that would bear the name of Wilmington, California, stenciled on the fuselage. The bomber campaign went over the top by $212,000. (Courtesy of Security Pacific Collection/Los Angeles Public Library.)

In 1944, the fourth of Wilmington's War Loan Drives was kicked off with a 774 tank in front of the Fox Granada Theater on Avalon Boulevard. The price of admission was a war bond. Wilmington's quota was $2 million for the drive. Wilmington exceeded the quota by $8,850, relieving the shortage for Southern California totals. Both drive chairmen, Elmer J. Rossman and Anna Snyder, resided in the Banning Wrigley Historic District. (Courtesy of National Archives, Pacific Region, Laguna Niguel.)

Boy Scout Troop 221 and other Wilmington Boy Scout troops often received their badges and were honored with awards for the tens of thousands of dollars they managed to get pledged for saving bond drives by going door-to-door and house-to-house. The Rotary Club sponsored these local heroes. Their scoutmaster was Dr. Joseph Silveria, and his aids were Joseph Denni and Louie Newman. Pictured from left to right are (first row) ? Harper, John Burch, and Harold Harper; (second row) Ralph Fogel, Jim Roberts, and John Nerad; (third row) Eugene Schmitz, Jerry Huddleston, and Robert Warriner. Nerad resided in the Banning Wrigley Historic District. (Courtesy of John Nerad.)

For soldiers who were wounded or ill when they returned, the Los Angeles Port of Embarkation hosted hospital ships, including the USS *Comfort*, which was built at the Consolidation Steel shipyard in Wilmington. These ships were staffed and operated by the 205th Hospital Ship Compliment. After initial treatment, soldiers were moved to the recently opened Los Angeles Port of Embarkation Station Hospital (Harbor General) at Vermont Avenue and Carson Street, which could care for 1,000 to 1,300 troops. (Courtesy of National Archives, Pacific Region, Laguna Niguel.)

The Station Hospital of the Port of Embarkation at Wilmington received the first patients November 22, 1943, located at Carson Street and Vermont Avenue in what is now Carson. Staff included 35 doctors, 12 administrators, 50 nurses, 180 enlisted men, and 200 civilians. The building included 13 wards with a capacity of 33, seven combination wards of 26 beds, private rooms for officers, and a mental ward. The hospital was also equipped with a modern operating room. (Courtesy of Leon Calloway.)

On December 10, 1944, Consolidation Steel delivered the 500th vessel at the Wilmington shipyard located on West B Street. The large "M" above the center of the banner with the company name is the highest honor the federal government can award a shipyard. With the awarding of the maritime "M," Consolidated made a 100-percent sweep in the winning of government awards. (Courtesy of National Archives, Pacific Region, Laguna Niguel.)

This P-47 fighter is being loaded on a Liberty ship. These ships would hold an average of 29 airplanes below decks and 12 on deck. The Los Angeles Port of Embarkation loaded 21 such ships with 759 aircraft during World War II. (Courtesy of Los Angeles Public Library Port Signal Office.)

Pres. Franklin D. Roosevelt's memorial service at the port on April 14, 1945, is shown here. By this time, there were 4,483 civilian personnel working at the Port of Embarkation. Note the steam plant in the background. (Courtesy of National Archives, Pacific Region, Laguna Niguel.)

As the ships returned after the war, the soldiers and sailors were heartily welcomed home through the Los Angeles Port of Embarkation. Unfortunately, a drastic railcar shortage forced tens of thousands of troops to remain on board ship in the harbor. On Christmas Day 1945, the Los Angeles Port of Embarkation and the USO fed every GI a Christmas dinner courtesy of the American people. (Courtesy of National Archives, Pacific Region, Laguna Niguel.)

In the center are the three headquarters buildings of the Los Angeles Port of Embarkation at Water Street and Fries Avenue. The Coast Fishing Company is in the background. Indicative of the impressive financial size of the operation, payments to stevedoring and service companies at the Los Angeles and Long Beach harbor departments amounted to $29,180,123 in World War II dollars. (Courtesy of the Port of Los Angeles.)

This is the entrance gate sign to Camp Ross, which was located on 31 acres where Los Angeles Harbor College now stands. During World War II, this army camp housed as many as 5,045 persons, including Negro Quartermaster Services Troops and 405 Italian war prisoners. Camp Ross had a fire station, theater, a large warehouse building, which was also used as a post exchange and servicemen's lounge, and approximately 78 large barracks and 59 small living quarters. (Courtesy of National Archives, Pacific Region, Laguna Niguel.)

In an air view of Camp Ross taken February 12, 1946, from a navy dirigible, one can see how much land the camp encompassed. Looking northeasterly over Camp Ross, the Bixby Slough can be seen at the left. The only occupants at the camp at the time were a few guards and the firefighters that remained to protect government property. (Courtesy of the Port of Los Angeles.)

To relieve homesickness and tension of the war, a favorite pastime was playing softball, often before large crowds of spectators. The women's team at Camp Ross had no shortage of other teams to play against. Other camps, factories, shipyards, housing projects, schools, churches, and civic organizations formed teams and competed for fun, entertainment, prizes, and bragging rights. (Courtesy of National Archives, Pacific Region, Laguna Niguel.)

Unless it rained, there were several baseball games going on before and after working hours all over Wilmington. These teams had creative names such as Troop Movement, Staff Service, and the Wilmington Hall Diamonds. Seen here are members of the Camp Ross team posing after a game. (Courtesy of National Archives, Pacific Region, Laguna Niguel.)

Seen here are some of the finest African American troops of the Quartermaster Corps of the 541st Division and the 511th Port Battalion at Camp Ross proudly posing for a picture before leaving on a three-day pass. During World War II, the Quartermaster Corps trained thousands of soldiers for specialized roles in every theater of operations. At the height of the war, quartermasters were providing over 70,000 different supply items and more than 24 million meals each day. No other branch of the service can begin to rival the Quartermaster Corps for its diversity of tasks and the many functions it provides. (Courtesy of National Archives, Pacific Region, Laguna Niguel.)

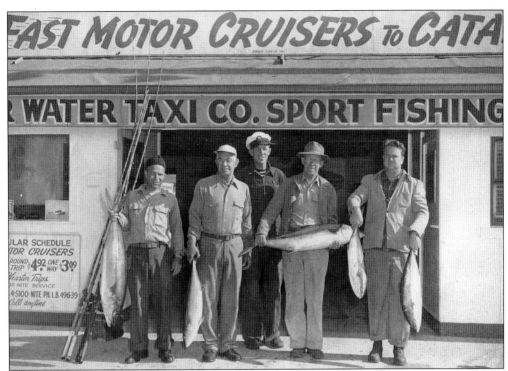

This small, one-story, nondescript structure played an important function in Wilmington's history. Located at 100 East Water Street, it housed the Water Taxi Company that transported hundreds of employees back and forth to work daily to the California shipyard on Terminal Island. The Pacific Electric streetcars brought shipyard workers from all over Los Angeles, stopping in front of this building. The Fast Motor Cruisers to Catalina along with sportfishing excursions also shared the building. Notice the fishermen proudly displaying their catch of the day.

In 1944, instructors and unit representatives attending a Joint Information Systems Technology (JIST) meeting take time out to pose in front of the headquarters of the Los Angeles Port of Embarkation. On April 1, 1946, the last units of the great sprawling army facility closed down. The land reverted to the U.S. District Engineer and was returned to the port. The buildings were declared surplus and sold or dismantled. (Courtesy of National Archives, Pacific Region, Laguna Niguel.)

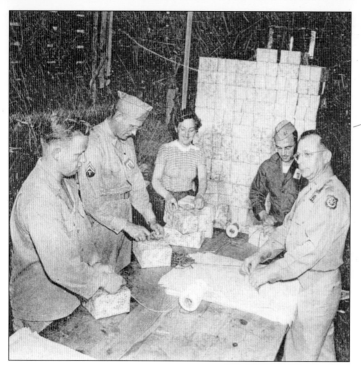

Chaplain David C. Colony and his staff are shown wrapping Christmas packages for overseas mailing at the Wilmington warehouses. The Manuel warehouse is still located between Pacific Coast Highway and Sepulveda Boulevard on the north Wilmington/Long Beach border. Supplies and equipment from all over the United States were stored in these three warehouses awaiting overseas shipment from the Los Angeles Port of Embarkation. (Courtesy of National Archives, Pacific Region, Laguna Niguel.)

As soon as the war ended, the 3,000 shipyard and aircraft war workers who had occupied Wilmington Hall returned to their homes all over the United States. This World War II emergency housing was demolished soon after. The only remaining relic of what was a small city is Wilmington Recreation Center at C Street and Neptune Avenue.

Newspaper article courtesy of the Wilmington Historical Society, P.O. Box 1435, Wilmington, CA 90748-1435
Printing courtesy of the Drum Barracks Civil War Museum, 1052 Banning Boulevard, Wilmington, CA 90744

WILMINGTON
Press-Journal

Press Established 1927 Journal Established 1864

ew Series: Vol. 3—No. 302 Published at Wilmington, California, Saturday Eve., May 29, 1948 United Press Leased Wire 5¢ per copy

☆
IN
☆
MEMORIAM
☆ ☆

Wilmington Honors War Dead

Homage to Wilmington's war dead is being paid today, as on Memorial Days in the past. Especially do thoughts go to those who gave their lives during the conflict so recently ended—the valorous heroes of World War II, whose supreme sacrifice brought Victory and a promise of permanent peace to a war-shattered, bleeding and suffering universe. In memory of these brave men and those of all previous conflicts, let our heads be bowed in silent and devout meditation.

WAR DEAD HONOR ROLL

Roy Anderson, Jerry Angelich, Oron Bearslee, Russell C. Boyce, Larry Bozarth, Donald Brewer, Bruce Brock, Thomas L. Brown, Donald W. Chrystal, Walter H. Cummings, Tony D'Ambrosi.

Joseph Dennen, Frank Dimond, R. D. Dixon, Allen (Ed) Elder, John T. Elkinton, Lowell Elliott, Ronald B. Ely, Jack B. Eyerly, Robert L. Fehrenbach, Walter Fike, Jr., Clinton C. Frey, Floyd L. Greene, A. F. (Archie) Hartman, Clayton J. Hayes, Fred Hoff, Jr., Leonard M. Huastes, W. H. Jackson, Arch Mack Laney, Jr., Pete C. Lara, Harold D. Leedom, Bryan Leet, Marion Legendre, Charles Lewis;

William Martin, Archie Marvel, Jesse McDaniels, James McFaddin, Matthew Mehxen, H. K. McKay, Wade Mitchell, Charles Mooneyham, Nick Noble, James E. Ocamb, D. Ocbp, Frank Ortiz, Susuma Okura, Norberto Pasamonte, John F. Putman (missing in action), William Puckett, William Schrouder Jr., William Skelton, George F. Snow, Bud Soza, Kenneth Stoddard, Joseph Trani, Leo Tavera, Henry Teran, Mike Terkla, Alfred Tomasini, Jr., Fred Donald Turner, Grover Uhl, Frank Winchester, Thomas Quealy and Vincent Ngoho.

We thank all the Wilmington military families that lost their loved ones in World War II. Their sacrifices were made so that this country would continue to be a great place to live.

ACROSS AMERICA, PEOPLE ARE DISCOVERING SOMETHING WONDERFUL. *THEIR HERITAGE.*

Arcadia Publishing is the leading local history publisher in the United States. With more than 4,000 titles in print and hundreds of new titles released every year, Arcadia has extensive specialized experience chronicling the history of communities and celebrating America's hidden stories, bringing to life the people, places, and events from the past. To discover the history of other communities across the nation, please visit:

www.arcadiapublishing.com

Customized search tools allow you to find regional history books about the town where you grew up, the cities where your friends and family live, the town where your parents met, or even that retirement spot you've been dreaming about.

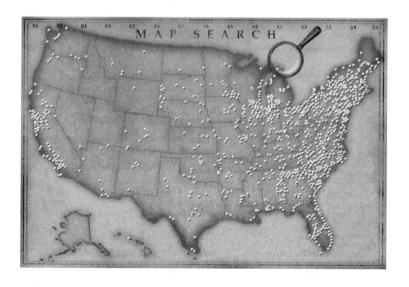